PAINT ALONG WITH JERRY YARNELL • *VOLUME FOUR*

PAINTING
Techniques

DATE DUE

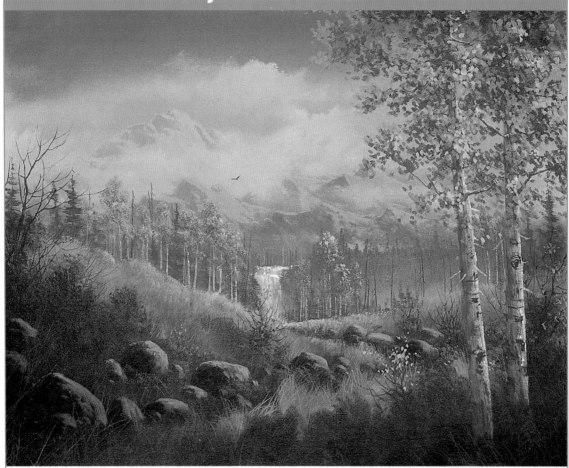

PAINTING

Techniques

NORTH LIGHT BOOKS

CINCINNATI, OHIO
www.artistsnetwork.com

ABOUT THE AUTHOR Jerry Yarnell was born in Tulsa, Oklahoma, in 1953. A recipient of two scholarships from the Philbrook Art Center in Tulsa, Jerry has always had a great passion for nature and has made it a major thematic focus in his painting. He has been rewarded for his dedication with numerous awards, art shows and gallery exhibits across the country. His awards include the prestigious Easel Award from the Governor's Classic Western Art Show in Albuquerque, New Mexico, acceptance in the top 100 artists represented in the national Art for the Parks Competition, an exhibition of work in the Leigh Yawkey Woodson Birds in Art Show and participation in a premier showing of work by Oil Painters of America at the Prince Gallery in Chicago, Illinois.

Jerry has another unique talent that makes him stand out from the ordinary: He has an intense desire to share his painting ability with others. For years he has taught successful painting workshops and seminars for hundreds of people. Jerry's love for teaching also keeps him very busy offering workshops and private lessons in his new Yarnell Studio & School of Fine Art. Jerry is the author of four books on painting instruction, and his unique style can be viewed on his popular PBS television series, *Jerry Yarnell School of Fine Art*, airing worldwide.

Paint Along With Jerry Yarnell, Volume 4: Painting Techniques. © 2002 by Jerry Yarnell. Manufactured in China. All rights reserved. No part of this book may be reproduced in any form or by any electronic or mechanical means including information storage and retrieval systems without permission in writing from the publisher, except by a reviewer, who may quote brief passages in a review. Published by North Light Books, an imprint of F&W Publications, Inc., 4700 E. Galbraith Road, Cincinnati, Ohio 45236. (800) 289-0963. First edition.

Other fine North Light Books are available from your local bookstore or art supply store or direct from the publisher.

06 05 04 03 02 5 4 3 2 1

Library of Congress Cataloging-in-Publication Data

Yarnell, Jerry.
 Paint Along with Jerry Yarnell.
 p. cm.
 Includes index.
 Contents: v. 4. Painting techniques
 ISBN 1-58180-318-4 (pbk. : alk. paper)
 1. Acrylic painting—Technique. 2. Landscape painting—Technique. I. Title

ND1535 .Y37 2002
751.4'26—dc21 00-033944
 CIP

Editor: Liz Koffel
Designer: Angela Lennert Wilcox
Cover designer: Brian Roeth
Production coordinator: Sara Dumford
Production artist: Christine Batty
Photographer: Scott Yarnell

DEDICATION

It was not difficult to know to whom to dedicate this book. I give God all the praise and glory for my success. He blessed me with the gift of painting and the ability to share this gift with people around the world. He has blessed me with a new life after a very close brush with death. I am here today and able to share all of this with each of you because we have a kind, loving and gracious God. Thank you God for all you have done.

Also to my wonderful wife, Joan, who has sacrificed and patiently endured the hardships of an artist's life. I know she must love me or she would not still be with me. I love you, sweetheart, and thank you. Lastly, to my two sons, Justin and Joshua: You both are a true joy in my life.

ACKNOWLEDGMENTS

So many people deserve recognition. First I want to thank the thousands of students and viewers of my television show for their faithful support over the years. Their numerous requests for instructional materials are really what initiated the process of producing these books. I want to acknowledge my wonderful staff, Diane, Scott and my mother and father for their hard work and dedication. In addition, I want to recognize the North Light staff for their belief in my abilities.

FOR MORE INFORMATION

about the Yarnell Studio & School of Fine Art and to order books, instructional videos and painting supplies contact:

Yarnell Studio & School of Fine Art
P.O. Box 808
Skiatook, OK 74070

Phone: (877) 492-7635

Fax: (918) 396-2846

gallery@yarnellart.com

www.Yarnellart.com

Table of Contents

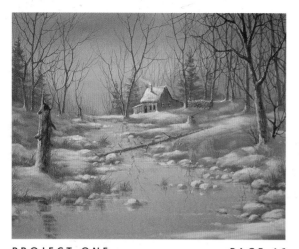

Winter Retreat

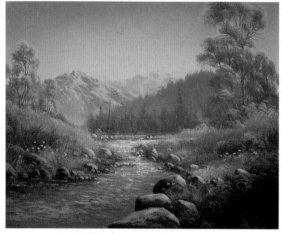

Summer Dreams

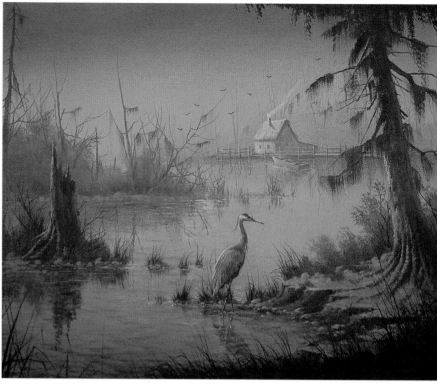

Swamp Fisherman

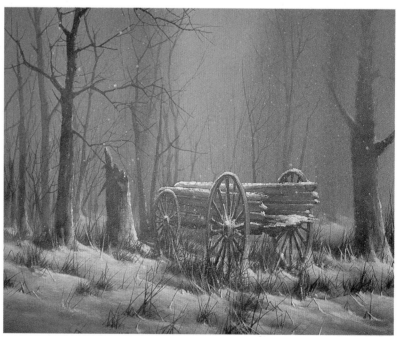

Reminder of the Past

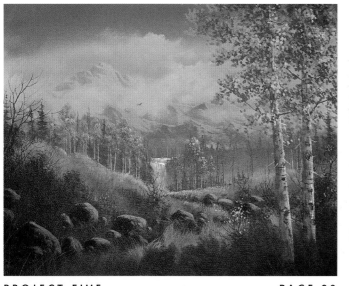

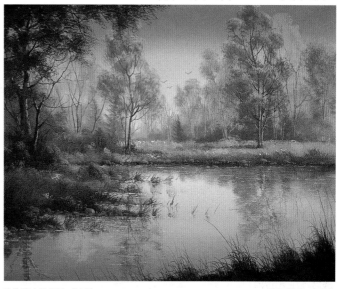

Autumn Fog in the High Country

Spring's Song

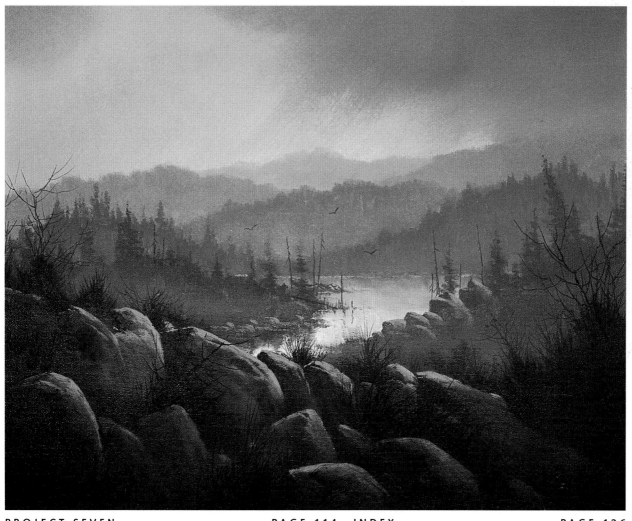

You Can See Forever

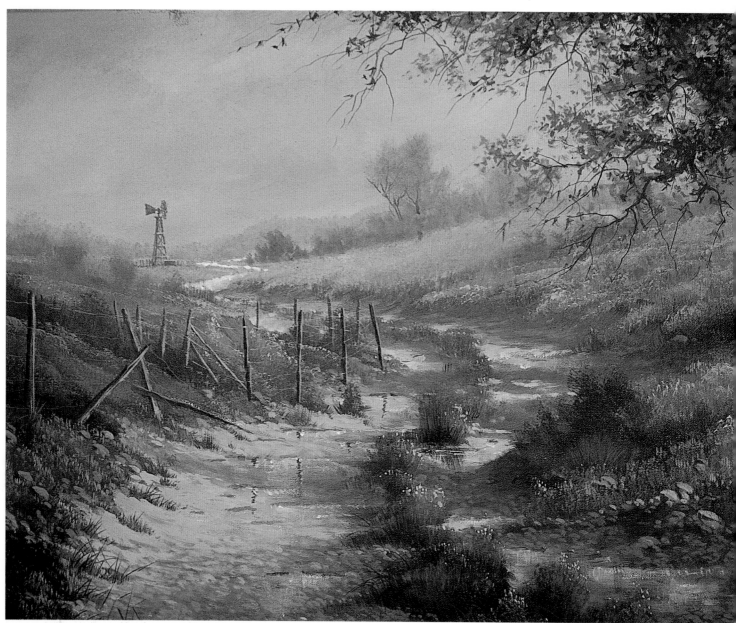

Texas Bluebonnets
15" × 30" (38cm × 77cm)

Introduction

Like most artists, you begin to expand your horizons as an artist. You begin searching for new ideas, subjects, techniques and ways to make your paintings stand out from the others. In this book my goal is to show you an array of different ideas that you can carry out to make your paintings more interesting and unique to you and your style of painting. I will illustrate to you that adding fog, mist or haze to an otherwise ordinary painting will change it into a painting that has much more eye appeal. You will understand the different applications of reflections in calm water and in moving water and how to create better reflections to help your water look wetter. Even adding simple mud puddles to a dirt road or pathway can dramatically change the atmosphere of your painting. You will also gain an understanding of how to create interesting trees by including dead trees and combining a variety of trees that give your painting good negative space. You will learn how to add final details, such as rocks, pebbles, a variety of grasses, weeds, bushes and other types of foliage that can really bring a landscape painting to life. This will be your opportunity to grab your brushes and create a truly unique work of art. I promise you will have a wonderful experience and a great time.

Terms & Techniques

Before beginning the step-by-step instructions on the following pages, you may want to refresh your memory by reviewing these painting terms, techniques and procedures.

COLOR COMPLEMENTS

Complementary colors are always opposite each other on the color wheel. Complements are used to create color balance in your paintings. It takes practice to understand the use of complements, but a good rule of thumb is to remember that whatever predominant color you have in your painting, use its complement or a form of its complement to highlight, accent or gray that color.

For example, if your painting has a lot of green in it, the complement of green is red or a form of red such as orange, red-orange or yellow-orange. If you have a lot of blue in your painting, the complement to blue is orange or a form of orange such as yellow-orange or red-orange. The complement of yellow is purple or a form of purple. Keep a color wheel handy until you have memorized the color complements.

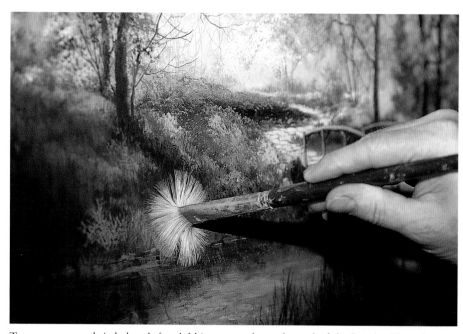

To prepare your bristle brush for dabbing, spread out the end of the bristles like a fan.

DABBING

This technique is used to create leaves, ground cover, flowers, etc. Take a bristle brush and dab it on your table or palette to spread out the ends of the bristles like a fan. Then load the brush with an appropriate color and gently dab on that color to create the desired effect. (See above example.)

DOUBLE LOAD OR TRIPLE LOAD

This is a procedure in which you put each of two or more colors on different parts of your brush. You mix these colors on the canvas instead of on your palette. This is used for wet-on-wet techniques, such as sky or water.

DRYBRUSH

This technique involves loading your brush with very little paint and lightly skimming the surface of the canvas to add color, blend colors or soften a color. Use a very light touch for this technique.

EYE FLOW

This is the movement of the viewer's eye through the arrangement of objects on your canvas or the use of negative space around or within an object. Your eye must move or flow smoothly throughout your painting or around an object. You do not want your eyes to bounce or jump from place to place. When you have a good understanding of the basic components of composition (design, negative space, "eye stoppers," overlap, etc.), your paintings will naturally have good eye flow.

FEATHERING

Feathering is a technique for blending to create very soft edges. You achieve this effect by using a very light touch and barely skimming the surface of the canvas with your brush. This is the technique to use for highlighting and glazing.

GESSO

Gesso is a white paint used for sealing the canvas before painting on it.

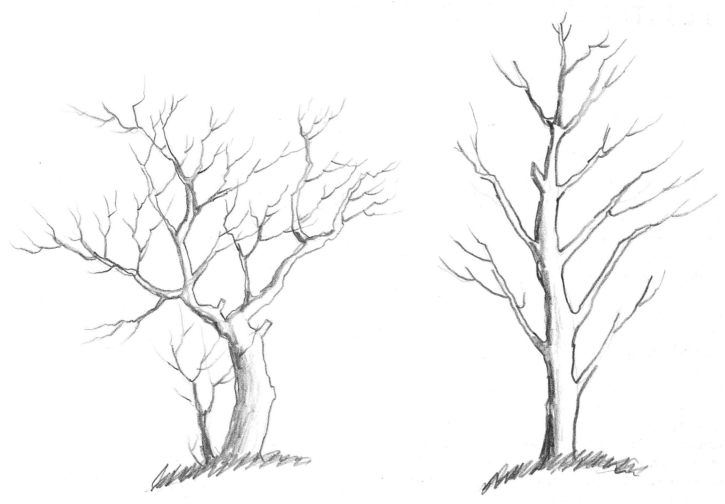

This is an example of good use of negative space. Notice the overlap of the limbs and the interesting pockets of space around each limb.

This is an example of poor use of negative space. Notice the limbs do not overlap but are evenly spaced instead. There are few pockets of interesting space.

However, because of its creamy consistency, I often use it instead of white paint; it blends so easily. I often refer to using gesso when mixing colors. Keep in mind that when I use the word *gesso* I am referring to the color white. If you don't use gesso for white, use Titanium White paint. Titanium White is the standard white that is on the supply list. Please feel free to use it if you prefer.

GLAZE (WASH)

A glaze or a wash is a very thin layer of paint applied on top of a dry area of the painting to create mist, fog, haze, sun rays or to soften an area that is too bright. This mixture is made up of a small amount of color diluted with water. It may be applied in layers to achieve the desired effect. Each layer must be dry before applying the next.

HIGHLIGHTING OR ACCENTING

Highlighting is one of the final stages of your painting. Use pure color or brighter values of colors to give your painting its final glow. Highlights are carefully applied on the sunlit edges of the most prominent objects in the painting.

MIXING

While this is fairly self-explanatory, there are a couple of ways to mix. First, if there is a color that will be used often, it is a good idea to pre-mix a quantity of that color to have it handy. I usually mix colors of paint with my brush, but sometimes a palette knife works better. You can be your own judge.

I also mix colors on the canvas. For instance, when I am underpainting grass, I may put two or three colors on the canvas and scumble them together to create a mottled background of different colors. Mixing color on the canvas also works well when painting skies. (Note: When working with acrylics, always try to mix your paint to a creamy consistency that can be blended easily.)

NEGATIVE SPACE

This is the area of space surrounding an object that defines its form. (See examples on page 11.)

SCRUBBING

Scrubbing is similar to scumbling, except the strokes are more uniform in horizontal or vertical patterns. You can use drybrush or wet-on-wet techniques with this procedure. I use it mostly for underpainting or blocking in an area.

SCUMBLING

For this technique, use a series of unorganized, overlapping strokes in different directions to create effects such as clumps of foliage, clouds, hair, grasses, etc. The direction of the stroke is not important.

UNDERPAINTING OR BLOCKING IN

These two terms mean the same thing. The first step in all paintings is to block in or underpaint the darker values of the entire painting. Then you begin applying the next values of color to create the form of each object.

VALUE

Value is the relative lightness or darkness of a color. To achieve depth or distance, use lighter values in the background and darker values as you come closer to the foreground. Raise the value of a color by adding white. (See example at right.) To lower the value of a color, add black, brown or the color's complement.

WET-ON-DRY

This is the technique I use most often in acrylic painting. After the background color is dry, apply the topcoat over it by using one of the blending techniques: drybrushing, scumbling or glazing.

WET-ON-WET

In this painting technique the colors are blended together while the first application of paint is still wet. I use the large hake (pronounced ha KAY) brush to blend large areas of wet-on-wet color, such as skies and water.

You can lighten the value of a color by adding white.

Getting Started

Acrylic Paint

The most common criticism about acrylics is that they dry too fast. Acrylics do dry very quickly through evaporation. To solve this problem I use a wet palette system, which is explained later in this chapter. I also use very specific drybrush blending techniques to make blending very easy. If you follow the techniques I use in this book, with a little practice you can overcome any of the drying problems acrylics seem to pose.

Speaking as a professional artist, I think acrylics are ideally suited for exhibiting and shipping. An acrylic painting can actually be framed and ready to ship thirty minutes after it is finished. You can apply varnish over acrylic paint or leave it unvarnished because the paint is self-sealing. Acrylics are also very versatile because the paint can be applied thick or creamy to resemble oil paint, or thinned with water for watercolor techniques. The best news of all is that acrylics are non-toxic, have very little odor and few people have allergic reactions to them.

USING A LIMITED PALETTE

As you will discover in this book, I work from a limited palette. Whether it is for my professional pieces or for instructional purposes, I have learned that a limited palette of the proper colors can be the most effective tool for painting. This palette works well for two main reasons: First, it teaches you to mix a wide range of shades and values of color, which every artist must be able to do; second, a limited palette eliminates the need to purchase dozens of different colors. As we know, paint is becoming very expensive.

So, with a few basic colors and a little knowledge of color theory, you can paint anything you desire. This particular palette is very versatile, and with a basic understanding of the color wheel, the complementary color system and values, you can mix thousands of colors for every type of painting.

For example, you can mix Thalo Yellow-Green, Alizarin Crimson and a touch of white to create a beautiful basic flesh tone. These same three colors can be used in combination with other colors to create earth tones for landscape paintings. You can make black by mixing Ultramarine Blue with equal amounts of Dioxazine Purple and Burnt Sienna or Burnt Umber. The list goes on and on, and you will see that the sky is truly the limit.

Most paint companies make three grades of paints: economy, student and professional. The professional grades are more expensive but much more effective to work with. The main idea is to buy what you can afford and have fun. (Note: If you can't find a particular item, I carry a complete line of professional- and student-grade paints and brushes. Check page 3 for resource information.)

MATERIALS LIST

Palette

White Gesso
Paints (*Grumbacher, Liquitex or Winsor & Newton: color names may vary.*)

- Alizarin Crimson
- Burnt Sienna
- Burnt Umber
- Cadmium Orange
- Cadmium Red Light
- Cadmium Yellow Light
- Dioxazine Purple
- Hooker's Green Hue
- Thalo (Phthalo) Yellow-Green
- Titanium White
- Ultramarine Blue

Brushes

2-inch (51mm) hake brush
no. 10 bristle brush
no. 6 bristle brush
no. 4 flat sable brush
no. 4 round sable brush
no. 4 script liner brush

Miscellaneous Items

Sta-Wet palette
water can
soft vine charcoal
16" x 20" (41cm x 51cm) stretched canvas
paper towel
palette knife
spray bottle
easel

Brushes

My selection of a limited number of specific brushes was chosen for the same reasons as the limited palette: versatility and economics.

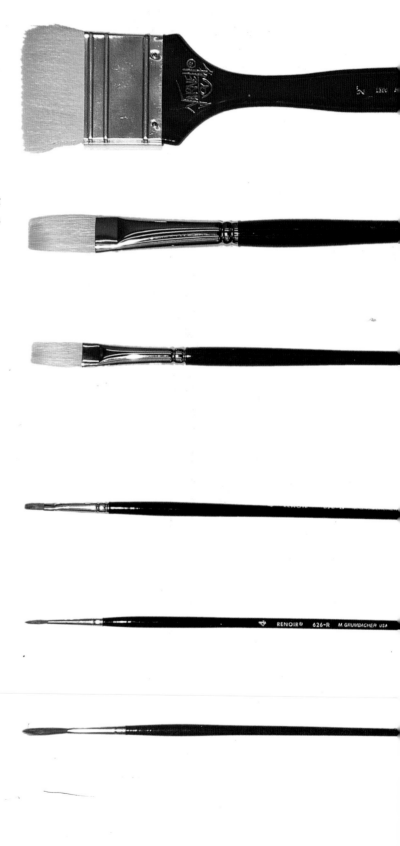

2-INCH (51MM) HAKE BRUSH

The hake (pronounced ha KAY) brush is a large brush used for blending. It is primarily used in wet-on-wet techniques for painting skies and large bodies of water. It is often used for glazing, as well.

NO. 10 BRISTLE BRUSH

This brush is used for underpainting large areas—mountains, rocks, ground or grass—as well as for dabbing on tree leaves and other foliage. This brush also works great for scumbling and scrubbing techniques. The stiff bristles are very durable, so you can be fairly rough on them.

NO. 6 BRISTLE BRUSH

A cousin to the no. 10 bristle brush, this brush is used for many of the same techniques and procedures. The no. 6 bristle brush is more versatile because you can use it for smaller areas, intermediate details, highlights and some details on larger objects. The no. 6 and no. 10 bristle brushes are the brushes you will use most often.

NO. 4 FLAT SABLE BRUSH

Sable brushes are used for more refined blending, detailing and highlighting techniques. They work great for final details and are a must for painting people and detailing birds or animals. They are more fragile and more expensive, so treat them with extra care.

NO. 4 ROUND SABLE BRUSH

Like the no. 4 flat sable brush, this brush is used for detailing and highlighting people, birds, animals, etc. The main difference is that the sharp point allows you to have more control over areas where a flat brush will not work or is too wide. This is a great brush for finishing a painting.

NO. 4 SCRIPT LINER BRUSH

This brush is my favorite. It is used for the very fine details and narrow line work that can't be accomplished with any other brush. For example, use this brush for tree limbs, wire and weeds—and especially for your signature. The main thing to remember is to use it with a much thinner mixture of paint. Roll the brush in an inklike mixture until it forms a fine point.

BRUSH CLEANING TIPS

Remember that acrylics dry through evaporation. As soon as you finish painting, use a good brush soap and warm water to thoroughly clean your brushes. Lay your brushes flat to dry. If you allow paint to dry in your brushes or your clothes, it is very difficult to get it out. I use denatured alcohol to soften dried paint. Soaking the brush in the alcohol for about thirty minutes, then washing it with soap and water, usually gets the dried paint out.

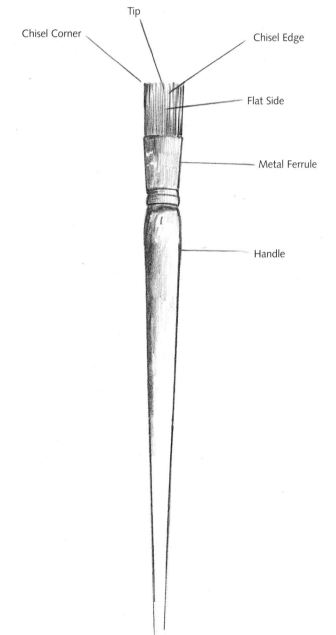

Chisel Corner

Tip

Chisel Edge

Flat Side

Metal Ferrule

Handle

Brush diagram

The Palette

There are several palettes on the market designed to help keep your paints wet. The two I use extensively are Sta-Wet palettes made by Masterson. Acrylics dry through evaporation, so keeping the paints wet is critical. The first palette is a 12" × 16" (31cm × 41cm) plastic palette-saver box with an airtight lid. It seals like Tupperware. This palette comes with a sponge you saturate with water and lay in the bottom of the box. Then you soak the special palette paper and lay it on the sponge. Place your paints out around the edge and you are ready to go. Use your spray bottle occasionally to mist your paints and they will stay wet all day long. When you are finished painting, attach the lid and your paint will stay wet for days.

My favorite palette is the same 12" × 16" (31cm × 41cm) palette box, except I don't use the sponge or palette paper. Instead, I place a piece of double-strength glass in the bottom of the palette. I fold paper towels into long strips (into fourths), saturate them with water and lay them on the outer edge of the glass. I place my paints on the paper towel. They will stay wet for days. I occasionally mist them to keep the towels wet.

If you leave your paints in a sealed palette for several days without opening it, certain colors, such as green and Burnt Umber, will mildew. Just replace the color or add a few drops of chlorine bleach to the water in the palette to help prevent mildew.

To clean the glass palette, allow it to sit for about thirty seconds in water or spray the glass with your spray bottle. Scrape off the old paint with a single-edge razor blade. Either palette is great. I prefer the glass palette because I don't have to change the palette paper.

Setting Up Your Palette

Here are two different ways to set up your palette.

PALETTE 1

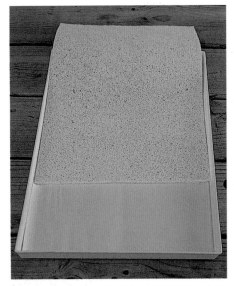

The Sta-Wet 12" × 16" (31cm × 41cm) plastic palette-saver box comes with a large sponge, which is saturated with water.

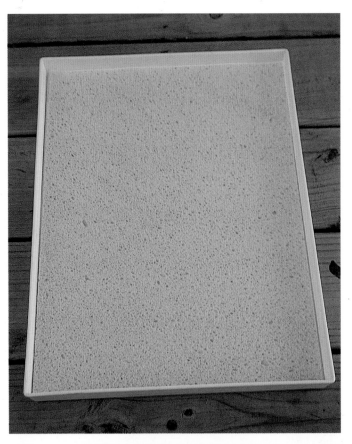

Lay the sponge inside the palette box. Next, soak the special palette paper and lay it on the sponge. Place your paints around the edge. Don't forget to mist your paints to keep them wet.

The palette comes with an airtight lid that seals like Tupperware.

When closing the palette-saver box, make sure the lid is on securely. When the palette is properly sealed, your paints will stay wet for days.

PALETTE 2

Lay the saturated paper towels on the outer edges of the glass.

Instead of using the sponge or palette paper, another way to set up your palette box is to use a piece of double-strength glass in the bottom of the palette. Fold paper towels in long strips and saturate them with water to hold your paint.

I place my paints on the paper towel in the order shown.

Use the center of the palette for mixing paints. Occasionally mist the paper towels to keep them wet.

To clean the palette, allow it to sit for thirty seconds in water or spray the glass with a spray bottle. Scrape off the old paint with a single-edge razor blade.

Miscellaneous Supplies

CANVAS

There are many types of canvas available. Canvas boards are fine for practicing your strokes, as are canvas paper pads for doing studies or for testing paints and brush techniques. The best surface to work on is a primed, prestretched cotton canvas with a medium texture, which can be found at most art stores. As you become more advanced in your skills, you may want to learn to stretch your own canvas. I do this as often as I can, but for now a 16" × 20" (41cm × 51cm) prestretched cotton canvas is all you need for the paintings in this book.

EASEL

I prefer to work on a sturdy standing easel. There are many easels on the market, but my favorite is the Stanrite ST500 aluminum easel. It is lightweight, sturdy and easy to fold up to take on location or to workshops.

LIGHTING

Of course, the best light is natural north light, but most of us don't have this light available in our work areas. The next best light is 4' or 8' (1.2m or 2.4m) fluorescent lights hung directly over your easel. Place one cool bulb and one warm bulb in the fixture; this best simulates natural light.

Studio lights

16" × 20" (41cm × 51cm) prestretched canvas

Aluminum Stanrite studio easel

SPRAY BOTTLE

I use a spray bottle with a fine mist to lightly mist my paints and brushes throughout the painting process. The best ones are plant misters or spray bottles from a beauty supply store. It is important to keep one handy.

PALETTE KNIFE

I do not do a lot of palette-knife painting. I mostly use a knife for mixing. A trowel-shaped knife is more comfortable and easier to use than a flat knife.

SOFT VINE CHARCOAL

I prefer to use soft vine charcoal for most of my sketching. It is very easy to work with and shows up well. You can remove or change it by wiping it off with a damp paper towel.

Spray bottle

Soft vine charcoal

Palette knives

Glazing

You may have seen me demonstrate washing techniques on my TV show or instructional videos. Most of the time, I am referring to a thin wash of water and a particular color that is applied over a certain area of the painting to create special effects, such as mist, fog, haze or smoke. However, the examples here show how to use glazing to create an intense highlight by applying one glaze on top of another. Glazing is truly an old master's technique, and the results can be phenomenal.

Glazing is an important technique to acrylic artists because the paint dries darker than when first applied. By layering one glaze on top of another, an acrylic artist can control the degree of brightness.

This rock is a good subject to study for practicing glazing techniques. Glazing works on any subject that needs to have a brighter highlight and good three-dimensional form.

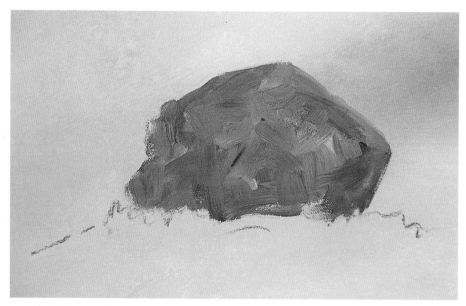

1 Underpaint the Rock

First, underpaint the object with its appropriate underpainting color. Be sure the canvas is completely covered (opaque). For this example, use a combination of Ultramarine Blue, Burnt Sienna, Dioxazine Purple, and a little white. Do not premix them all together on the palette to create one color. Instead, mix the colors on the canvas and mottle them so each individual color will show through the glaze. Use a no. 6 bristle brush for this step.

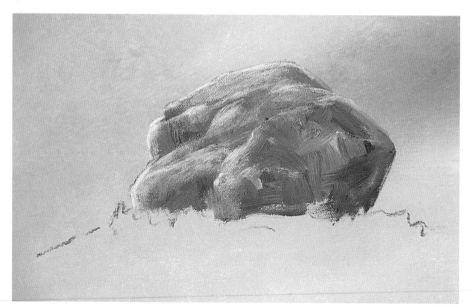

2 Mix Glaze and Apply

Now mix the first layer of highlight color, which I call the "sunshine color." Mix white with a touch of orange and yellow, and thin it slightly with water. The consistency should be like soft, whipped butter. Load a no. 4 flat sable brush with a small amount of paint on the end of the bristles. Gently drybrush the first layer of highlight on the top right side of the rock, carefully blending the highlight color into the underpainting. Be sure the edges are soft, not harsh. Also, some of the background color must show through in order for this process to work.

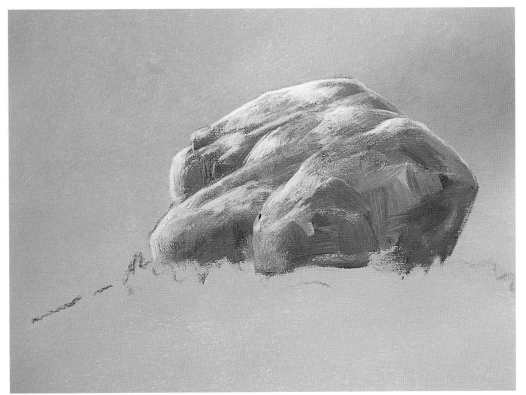

3 Apply Another Layer
This step and the next step are identical to step 2. Use the same brush and the same highlight color. You will drybrush other layers on top of the first. Be sure each layer is dry before applying the next. Remember, this is a glaze and each layer is a thin layer of paint. Notice that these steps make the rock appear brighter.

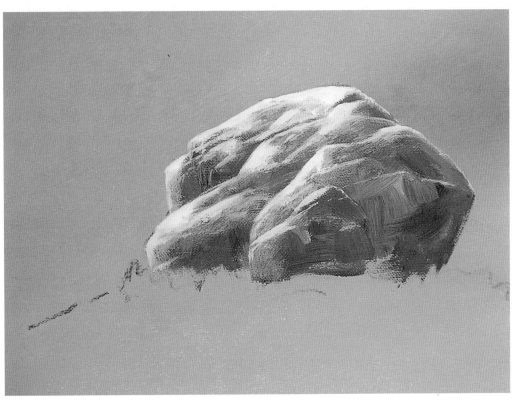

4 Add Final Layer
In this final glaze, you may want to be more selective as to where you place the paint. You do not have to cover the entire highlighted area, but notice that the rock is brighter now than the step before. You can add as many layers of glaze as you wish to create the desired effect.

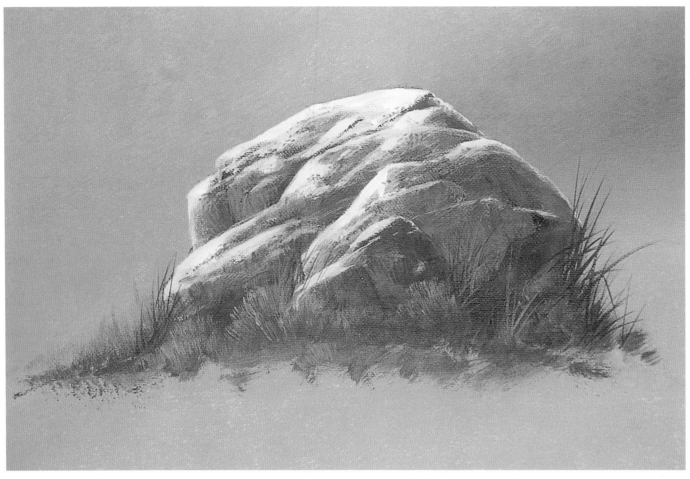

5 Add Details

This is a final detail step and has very little to do with glazing. Seeing the finished product helps you understand the importance of glazing. In this step, you add cracks and crevices, adjust the dark areas in the rock, or make other final touches. My best advice is never to finish an object all in one step. It is best to do things in stages. You will have greater success and have more control over your painting.

A Word About My Mixing Technique

The phrases "a touch of this and a dab of that" can make my instructions sound like a cooking show, but I have adopted this style of mixing because it is well suited for my style of painting. There are two main reasons why this style of mixing works so well. First, I am not a formula painter. Many artists have formulas that they use to premix numerous colors and values before they begin a painting. While this technique is widely used, it is very time-consuming and sometimes frustrating. After all that work, the colors and values may not fit into your color scheme. You may end up remixing or adjusting the color.

Using my technique, for example, gray is a base mixture of white, blue and Burnt Sienna. If I want it to be on the bluish side, I will mix white with blue and a touch of Burnt Sienna, but increase the blue. This makes the blue predominant and creates a bluish gray color. If I want a brownish gray, I mix white with extra Burnt Sienna and just a touch of blue. If I want a purple tint, I add a touch of purple. There are literally hundreds of gray combinations based on the colors that are most prominent. This same technique applies for all color schemes. Experiment with this mixing technique, and you will find it very exciting and helpful to your painting experience.

Another reason I prefer my mixing technique is that as a professional instructor who works with people from all over the world, I've learned there are many different brands of paint. Some brands do not match others, and some paints are weaker in pigment than others. There are three different grades of paint: economy, student and professional grade. A formula mixing technique can't work with all of these different paints. With my technique, adding a touch of this or a larger dab of that is a very quick and easy way to adjust a value or color. With a touch of this and a dab of that, I am not trying to create a tasty dish, but rather trying to simplify your mixing problems.

My mixing technique doesn't require you to measure out your paint.

Painting Fog, Mist and Haze

To the average person, fog, mist and haze may seem relatively dreary; however, to an artist, these atmospheric conditions can create excitement and an opportunity to transform an ordinary painting into an extraordinary work of art. The main focus in these studies is to learn when, where and how to use fog, mist or haze to create the most appropriate effect to your painting.

Imagine an early morning fog rising up from a rolling river or a placid lake. This type of atmosphere can add tremendous interest to an otherwise simple landscape painting. Adding a light mist over an entire painting can create the effect of a damp day or light rain. Learning how to create haze will give you the opportunity to add conditions like dust, smoke or sun rays. These things will add great eye appeal to your artwork and add a professional quality. There are many applications for these conditions and we will discuss only a few of them, but keep in mind the sky is the limit.

Fog

We will begin by learning the proper use, application and technique for creating fog. Painting fog is very much like painting a low-hanging cloud. Acrylic artists easily achieve this effect by using a dry-brush technique, which is the most effective way to create fog. This technique can also be used by oil painters so long as the underpainting is dry.

The most crucial thing to remember about fog is that it is usually located at the base of mountains, in low or depressed areas of a landscape or in valleys between hills or a mountain range.

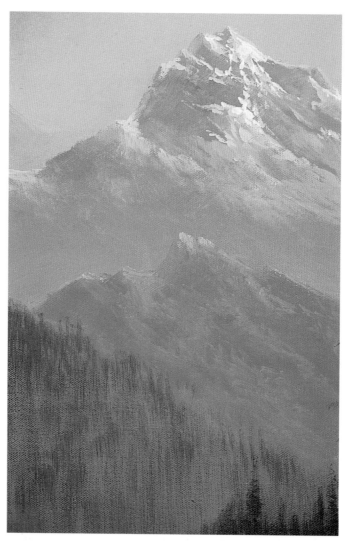

Fog Studies
Notice in these two examples that the fog at the base of the mountain adds much more interest.

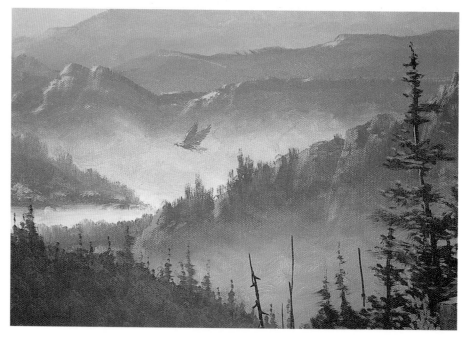

Making Fog

First of all, you want to make sure that you are completely finished with the underpainting or background subjects and that your painting is thoroughly dry. Now, choose the appropriate size and type of brush. Generally you use one of the flat bristle brushes, and only you can decide what size, which depends on the amount of area you need to cover and the location of the fog. A no. 4, no. 6 or no. 10 flat bristle brush will give you a good variety of choices. In this example I will use a no. 6 flat bristle brush.

You must choose the proper color and density of the fog. Let us look at these color swatches to help with this decision. (Note: The key here is to check the color of the subject where the fog will be applied and use a form of its complement.)

When I make fog, I like to use my brush to mix colors, but a palette knife may be your preference. Take a small amount of gesso or white paint and add a very small touch of the appropriate complement. Apply a small amount to the brush and begin at the base of the object you intend to fog. Use a series of overlapping scumbling strokes with a dry-brush technique until you have completely softened all of the edges of the fogged area. Once you have completed this process and it has thoroughly dried, you may repeat the process until you reach the degree of opaqueness that you desire.

Fog Example 1
A blue-gray background would need a slight hint of orange in the fog. This swatch shows you the background color without fog. With the fog added, notice how much softer the background becomes.

Fog Example 2
If you have a purplish tone in your background, you would want a slight yellow tint in the fog. Please remember you can use many different combinations. If you stick to the basics and use the complements properly, your painting will be pleasing.

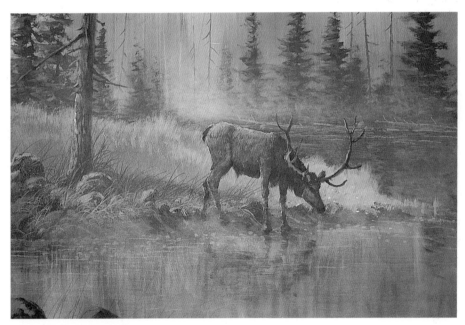

Fog Adds Atmosphere
Let us take a look at a finished painting and see how the fog really changes the atmosphere of the painting. Especially notice the soft blended edges.

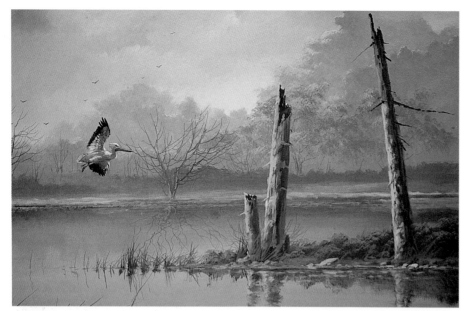

Three Fog Studies

Take a look at the three versions of this painting and notice the different degrees of opaqueness. In the top example, I've used no fog. In the middle painting, I applied a light fog. In the bottom painting, I used a medium to heavy fog. Remember that the key to good fog is to use a dry-brush scumbling stroke, blending out the edges of the fog so they are very soft. Make sure each layer of fog is thoroughly dry before adding additional layers.

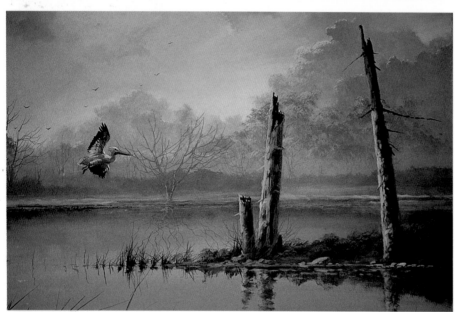

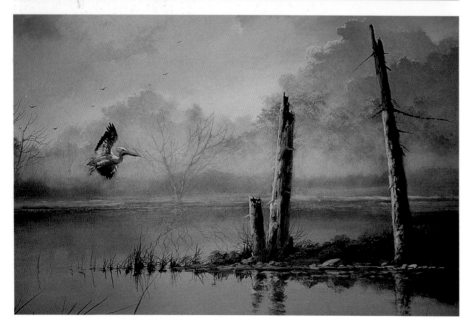

Mist

Mist is another atmospheric condition that really adds great eye appeal and interest to certain paintings. Unlike fog or haze, mist is generally limited to a damp, rainy or snowy atmosphere.

Painting mist is generally a transparent process, and it is applied by using a series of glazes or washes with your large hake brush. Since mist is almost always associated with wet conditions, you will use tones of gray to paint your background. This is really a big help because gray tones make applying the mist easier.

Making Mist

To mix a mist, first take a small dab of gesso or white paint and add enough water until you create a fairly thin transparent wash. This could have a slight tint of red, orange, yellow or even a combination of these colors. Wet the hake brush and squeeze out the excess water with your fingers and form a chiseled edge. Evenly load the brush across the chiseled edge until it is completely saturated with the mist color.

Carefully drag your brush across the surface of the canvas, beginning at the top. Use even pressure and go all the way from the top to the bottom. Gradually move across the canvas, slightly overlapping the previous strokes, until the entire surface is covered. The angle of the stroke is up to you. The more angled the stroke, the windier the weather will appear. Straight or more vertical strokes appear calm.

Once you complete the mist, you can add other atmospheric conditions, such as raindrops or snow. Have fun experimenting. There are many options.

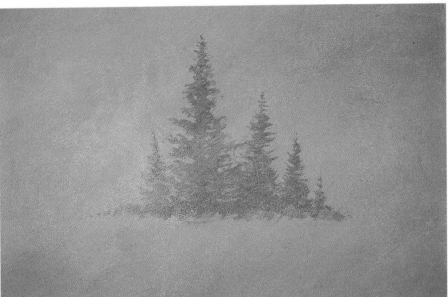

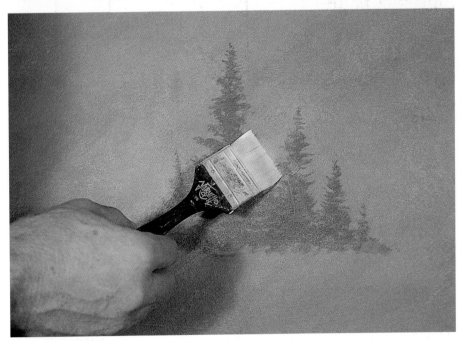

Applying Mist With a Hake Brush

Mist Examples

In these two studies, the example on top has a soft blue-gray background without mist. The study on the bottom has the same background, but I've applied mist.

Haze

Haze is a wonderful complement to any painting. In fact, haze is used in one form or another in most paintings. Let me give you examples of when the technique of creating haze is used: dust kicked up by a passing wind; a pickup truck rumbling on a dirt road; a hazy smoke from a distant forest fire; sun rays breaking through the clouds after a storm; dust kicked up from a thundering herd of horses or animals on a dry African plain. Haze is also used to soften or tone down an entire painting that is too intense or to soften an edge on certain objects, to blur a background or to create depth of field.

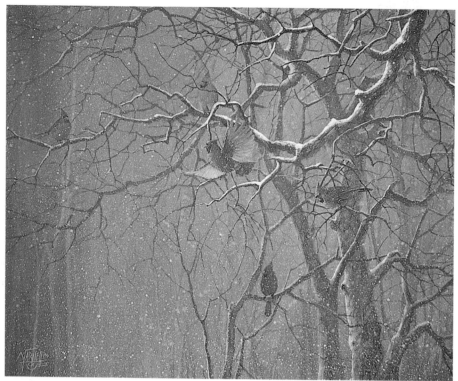

Haze Example 1
Notice in this painting the overall softness. The mist not only softens the painting, but it pushes some of the tree limbs and a few of the cardinals farther into the background. The feature cardinal can then be added on top of the haze so that it stands out.

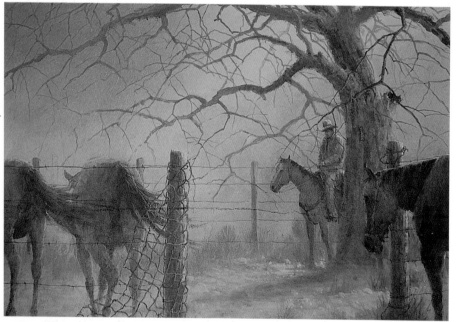

Haze Example 2
Notice how the haze in this detail of a larger painting not only softens the painting, but in this case creates the suggestion of dust kicked up by the horses. This is another wonderful use for haze.

Haze Example 3
In this painting the haze helps to diffuse the glow from the lights, thus giving the painting an almost eerie effect that works well in a night scene.

Making Haze

When you create haze, remember that you can apply as many layers as you desire to create the effect you're after. But each layer must be dry before adding the next layer of haze. Follow along with these steps to see how it's done.

1 Select the Proper Brush
Make sure your painting is completely dry. Select the proper brush. I normally prefer to use my hake brush because a haze usually covers a large area. If you are hazing a smaller area, your no. 10 bristle brush works well.

2 Mix the Haze Color
Mixing the proper haze color is important. It is best to choose a color that blends well with your color scheme and that complements the underpainting. Hopefully by now you know your complementary colors. Mix the haze color with white and plenty of water to create a wash, then add a small amount of the appropriate complement. Wet the area in which you are going to apply the haze. Take your mixture and use crisscross strokes to cover the entire area. Note: It will appear to be slightly milky. This is normal. As it dries, it will turn into a nice soft haze.

3 Make Minor Corrections
Now I'll show you one of the tricks of the trade. There is a good chance that you will haze over an object that you do not intend. To correct this, you immediately take a slightly damp paper towel and blot the area carefully to remove any unwanted haze. You will probably do this more often than not.

Painting Reflections

Painting reflections is one of the most exciting adventures in landscape painting. I would like to take a more in-depth look at painting reflections in calm water, moving water and simple things such as mud puddles. Look at the three studies to the right to see examples from my own artwork.

Painting Calm Water

It is important that you understand that the colors reflected are always those directly above the water area. For example, if you have a gray sky, the underpainting for your water will be a similar sky color. Then objects that are close enough to the water will be reflected, such as mountaintops, trees, grass, rocks and weeds. These objects will be reflected with their original color.

Once the issue of color is settled, the next question that always comes up is, how do I know how long the reflection should be? I can give you a basic rule that will solve most reflection-length problems, and good composition skills should take care of the rest of the problems. Study the simple illustration on the next page to determine the length of your reflection. Then follow along with the steps to see how easy it is to create calm water reflections.

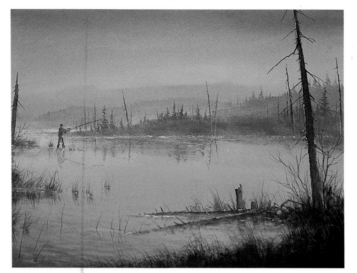

Reflection Study A: Calm Water
The calm water here helps to create a peaceful and tranquil atmosphere, which is the main use for calm water.

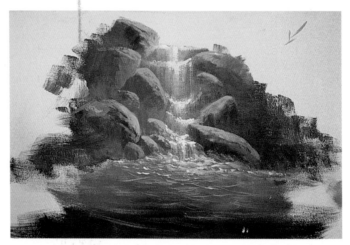

Reflection Study B: Moving Water
In this case the moving water creates excitement and action. Use this most often in paintings where action is the main part of the atmosphere.

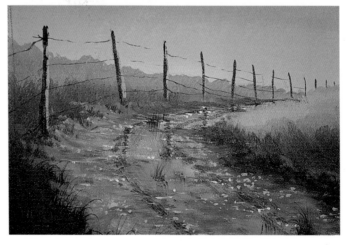

Reflection Study C: Mud Puddles
Mud puddles add interest to an otherwise dull landscape, and they are great fun to paint. They also help to create the atmosphere of a rainy day or a time just after a passing storm.

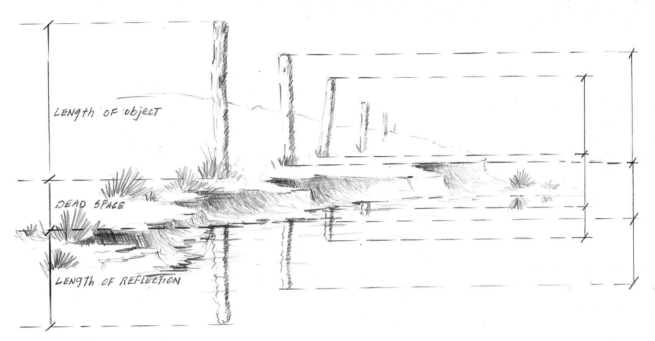

Calm Water Reflection Study

After locating the body of water, paint in your objects. Measure the length of an object—for instance, the fence post. Then, beginning at the bottom of the post, measure down directly below into the water and place a mark there. This will be the length of the object reflected in the water.

Note: Be sure you always measure from the bottom of the object, not the edge of the water. Notice how each fence post recedes into the distance the farther from the water's edge it is. Therefore, you see less of each fence post reflected in the water.

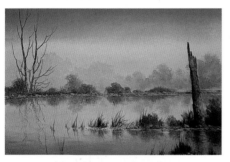

1 Paint Background and Reflective Objects

Paint the background for your water, which is generally the same basic color as your sky. After the background dries, paint in each reflective object. Start with the objects that are farthest away from the water. Then add the next closest objects.

Note: Be sure the color of your reflections is a close but toned-down version of the object being reflected. Use a dry-brush stroke, scrubbing to make sure your edges are soft and slightly blurred.

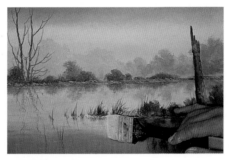

2 Glaze the Water

Once you have completed the reflections, you need to glaze the water with a mixture of water and a touch of white. Using your hake brush, turn it vertically to the canvas; lightly drag it across the water, creating a much softer reflective quality. You can repeat this step if you feel the need.

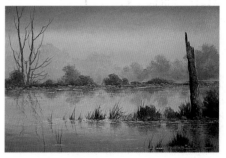

3 Add Highlights

At this time you can paint in some final accent highlights to give the water a little sparkle. This step is very simple. Take pure gesso and your no. 4 round sable brush and drybrush in some very thin slivers of bright highlights. These horizontal highlights go mostly along the shoreline or any place where the water may be slightly rippled.

Moving or Rippled Water

The techniques we used in painting calm water apply when painting moving water, as well. The main difference is that when you paint the reflections, you use loose, irregular strokes to create blurred edges. Look at the studies on this page to get a better idea of the effect of moving or rippled water.

Keep in mind that there are many variations of moving water, so there is no magic formula for creating perfect water. My job is to give you good technical advice. Then your job is to be very liberal with your artistic license.

Follow along with the steps on the next page to see how to make it all work. I used a no. 4 flat sable brush, no. 4 round sable brush, no. 4 flat bristle brush and a no. 6 flat bristle brush.

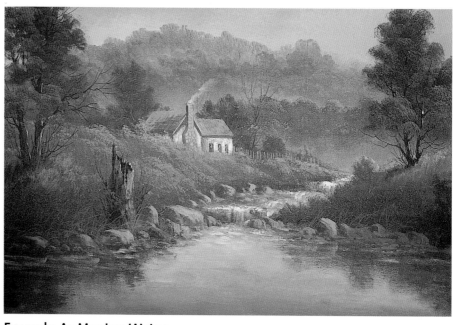

Example A: Moving Water

Notice in this autumn painting how the moving water really adds interest and life to the atmosphere. When you don't really have any major activity going on in your painting (in terms of a major center of interest), a little moving water will go a long way in bringing your painting to life.

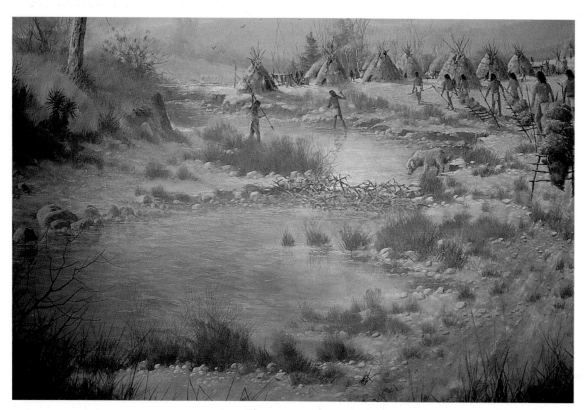

Example B: Moving Water

In this particular setting, the moving rippled water is actually a major part of the center of interest. The Indians spearing fish in the stream tie the water right into the main focal point.

1 Underpaint the Water

Again, you will paint the water's underpainting using the same sky color. The same process for adding the reflected objects applies here just as it did in the calm-water studies, except for one main difference: As you add the reflected objects, they should be blurred. This begins the process of making the water look like it is moving. A no. 4 or no. 6 bristle brush works best in this step.

2 Add Ripples

Now, at the front of the water we are going to add ripples. We do this by darkening the original sky color by adding more Burnt Sienna, Ultramarine Blue or Dioxazine Purple. Take your no. 6 bristle brush and start at the front of the water area. Use choppy overlapping strokes to create the suggestion of ripples. These should be fairly horizontal strokes. Gradually work your way up toward the shoreline, using less pressure and more space between strokes.

3 Highlight the Ripples

Now, you will highlight the ripples, which will give the water more movement. When you add your highlights, you will use a no. 4 flat sable brush and a no. 4 round sable brush. Mix a very creamy mixture of gesso and a touch of Cadmium Yellow Light or Cadmium Orange. Highlight the edges of the darker ripples. The paint should go on very opaque so it will stay clean and bright. There will be a heavier concentration of these highlights along the shoreline and around the objects in the water such as rocks and grass.

Mud Puddles

It is amazing what a few puddles of water will do for an otherwise ordinary dirt road, pathway or city street. We will not spend much time here because the process is the same as that for painting moving or calm water. The main difference is that puddles are just on a smaller scale. The only other difference is that your road or pathway needs to be completed first. Then you add your puddles on top.

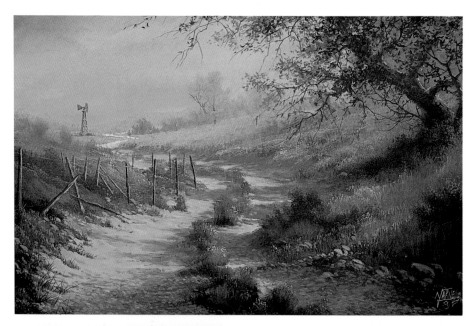

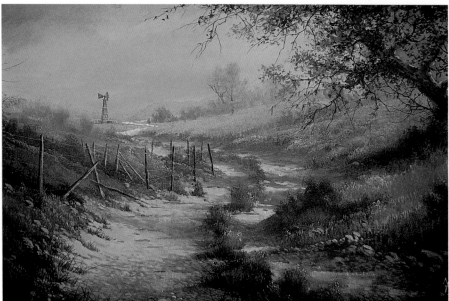

1 Finish the Background
Finish your road or background area. Allow it to dry completely.

2 Add Puddles
Drybrush the basic shape of the puddles using your sky color and a no. 4 or no. 6 bristle brush. Be sure your brushstrokes are fairly horizontal so the puddles appear flat.

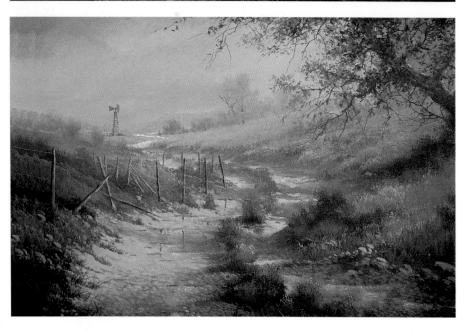

3 Add Reflections
Paint in any reflections of any objects that are directly above the puddles. Some puddles may not have any reflected objects, so just using the sky color and a few highlights will be all that is necessary.

Painting Trees

Trees are a major part of most landscape paintings, with the exception of treeless landscapes, such as ocean, desert or sky scenes. Good technical understanding is very important to the composition of a tree. Learning the proper way to underpaint and detail a tree and how to arrange a collection of trees is absolutely necessary in order for your painting to hold its technical, compositional and artistic integrity.

We will look at how to paint both live trees and dead trees. There are hundreds of different species of trees, therefore I am not going to discuss all of the tree types, but rather show you good painting and design techniques that you can apply to any species you choose to paint.

I want you to look at a very common problem when constructing trees. Uniform shape is one of the biggest issues I face when critiquing students' artwork. We are taught in life to line things up, keep things straight and organized. Unfortunately, sometimes we carry these characteristics into our paintings. The best example of this is when painting pine trees, but it also applies to other trees, as well.

Study these two examples to gain a better understanding of how negative space affects the design and composition of your trees.

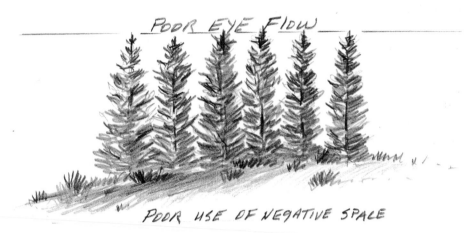

Example A: Poor Composition

In this study, the trees are poorly arranged. Note the negative space is all the same; the trees are all the same height and the same distance apart.

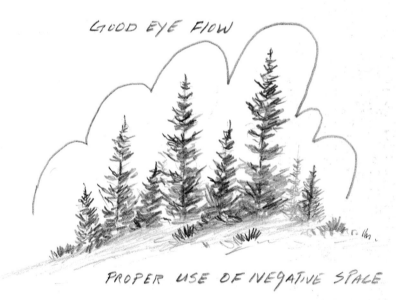

Example B: Good Composition

In this study the trees have the same basic layout as in Example A, but notice the proper use of negative space. This changes the entire look of this collection of trees so that not only are they now compositionally correct, they are also much more appealing to the eye.

Dead Trees

Look at these examples from my own work to better understand working with dead trees. These examples are similar except for the composition and subject matter. The main feature I want you to notice here is the proper use of negative space. This gives each tree good eye flow and interest. Notice the overlapping limbs, which create the negative space. It is how you overlap limbs that makes or breaks your trees. Not only is the individual design of the tree important but also notice the overall view. Observe how each tree works well with the entire composition.

Dead Tree Example A

Notice in this painting how the stump is shifted to the right of the center of interest. It is fairly close to the edge of the canvas, and it leans slightly in toward the center of the painting. This slight shift and leaning creates more interesting negative space around the stump. By adding additional dead limbs, texture and highlights, you create an interesting and unusual object.

Dead Tree Example B

Notice in the painting above how much the dead tree enhances the painting. It acts as an eye stopper on the left side of the painting. It is a major part of the composition. And it adds tremendous interest to the entire setting. Notice how the limbs that overlap the center of the painting help draw your eye into the main focal point or center of interest (the buildings).

Painting Stumps

A dead tree stump can add tremendous character to your painting. However, tree stumps do have their own design problems that we must overcome. Because of its straight cylinder shape, a tree stump is not all that interesting. For this reason we use our artistic license to make a stump really come alive.

Study the sample at right, and then follow along with the steps below. In this painting, the large tree has one main purpose. It is a critical eye stopper that gives the painting its balance. It does have a secondary function of adding interest to the painting, but notice that as large and interesting as the dead tree is, it does not interfere with the main center of interest.

Stump Study

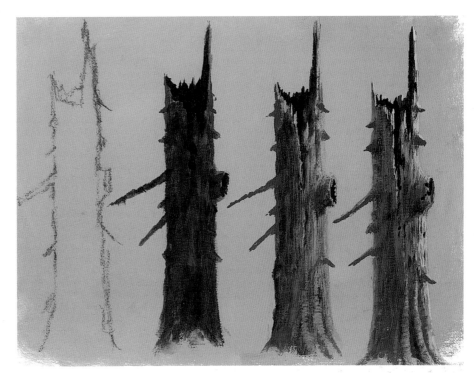

Step 1
First, make a rough sketch.

Step 2
Now, with a no. 6 bristle brush, underpaint the stump, using a mixture of Ultramarine Blue, Burnt Sienna and a touch of purple with a small amount of white. Use short choppy vertical strokes so that it looks rough and textured. Then with a no. 4 round sable brush, add the broken limbs.

Step 3
Highlight the tree using a mixture of white with a touch of orange. Use the no. 4 flat sable brush and once again use short choppy vertical strokes. Be sure you allow some of the background to come through so that you create the effect of rough tree bark.

Step 4
Add the final details: small holes and the reflected highlight. The reflected highlight is a mixture of white, blue and purple. Drybrush this reflected light on the back side of the tree to create soft rounded edges.

Painting Tree Branches

Now we are ready for one of the most exciting aspects of painting leafless trees. For this process you will use a no. 4 script liner brush. We are going to learn how to paint the smaller limbs that finish out a larger tree and also small bushes or saplings. For the sake of practicing, make a mixture of Burnt Sienna, Ultramarine Blue and plenty of water to create an inky mixture. The way this works is you take your script brush and fully load it by rolling it around in the mixture until the brush comes to a fine point.

Starting at the base of the limb, use heavy pressure and move upward, gradually decreasing the pressure until the limb tapers to a fine point. Use this same process for all smaller limbs, whether they are horizontal, slightly angled or vertical. When you add additional limbs to larger limbs, always start a little farther back on the existing limb and pull the attached limb out or upward.

Never begin painting a limb from the sky area inward, because you will usually leave a blob we call a bird's nest. It takes practice to master this brush, but you will eventually get it. Look at these examples to see how the tree gradually changes.

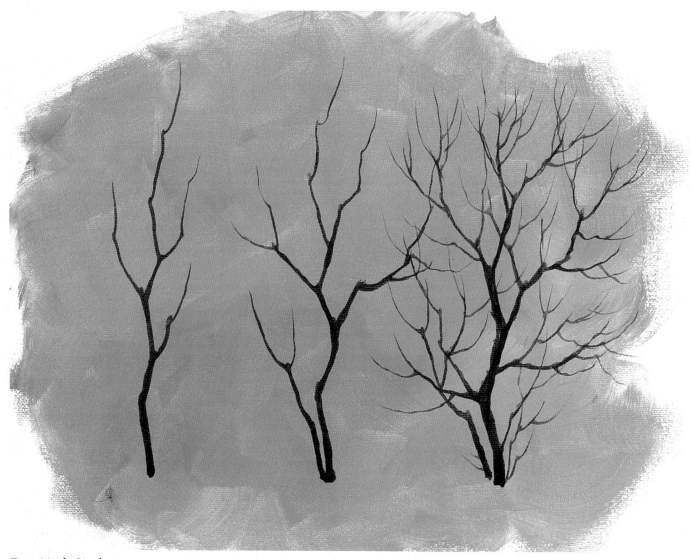

Tree Limb Study

Painting Live Trees

It is time to learn how to paint live trees. Knowing how to paint a leafed tree can be an asset to your painting, as long as the tree has good three-dimensional form. On the other hand, a tree that has poor form can be a real eyesore.

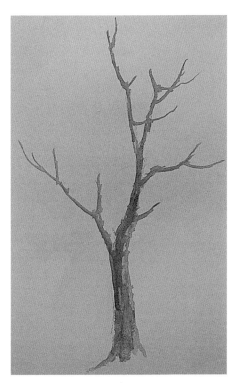

1 Block in the Trunk

Block in a rough tree trunk with no details, highlights or limbs—only the main trunk and main limbs. You will add the smaller limbs later. Block in the trunk with a no. 4 flat bristle brush with a mixture of Burnt Sienna and blue.

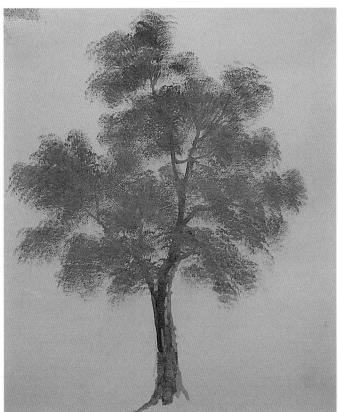

2 Form the Tree

Next, take your no. 10 bristle brush and mix an underpainting color of Hooker's Green, a touch of Burnt Sienna, purple and a little white to soften it. Load the end of the brush and dab straight on the canvas. As you start forming the tree, the most important thing to remember is to make sure your basic tree form has good negative space.

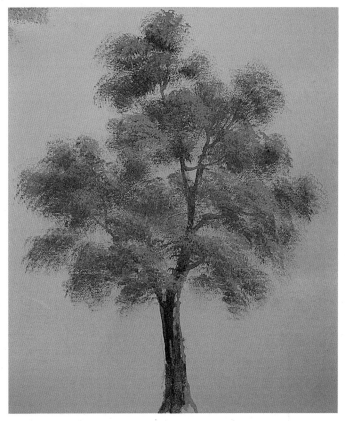

3 Add Highlights

Use the same mixture as in step 2. Change the value slightly by adding orange, yellow and white. You will use the same technique and dab in this value on the sunlit side of the tree. Begin by forming the clumps of leaves that gives the tree its shape. Be careful here because you do not want to overpaint too much of the background color or you will lose the depth in the leaves.

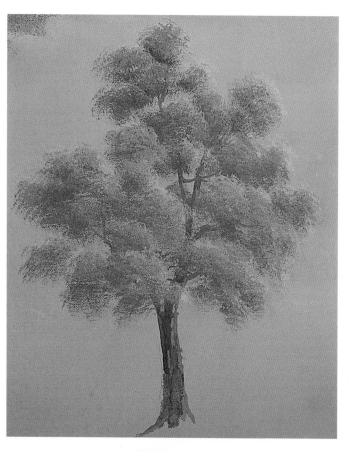

4 Add More Highlights

This step is almost identical to step 3. You will be adding the third and final value to the leaves. Take the same mixture as step 3 and make it much lighter. You need to add white and any or all of the following: yellow, Thalo Yellow-Green or orange. Dab on the final highlight carefully. Do not block out too much of the underpainting.

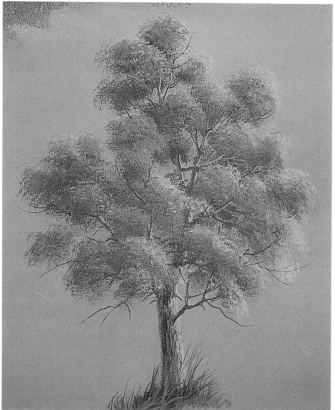

5 Add Final Details

Now you add final details and highlights. Use your script liner brush to add the final limbs up through the clumps of leaves. Then highlight the edge of the tree with a mixture of orange and white, using your no. 4 flat sable brush. The best advice I can give you is to paint loose and free. Make sure you leave good negative space in, around and through the tree.

Painting Rocks

Painting rocks is one of the more challenging components of a landscape painting. Rocks are also interesting because of their different shapes, colors, formations and sizes. From tiny pebbles to massive boulders, they all play a major role in the compositional makeup of a landscape painting. Let us look at a couple of examples on the right of my own work where rocks played an important role in the overall composition.

In both of these examples notice how the rock formations create balance in the painting. The rocks have good negative space around them. Observe how they overlap or touch each other to create good eye flow and also serve as eye stoppers. You can see how important rocks can be to your painting.

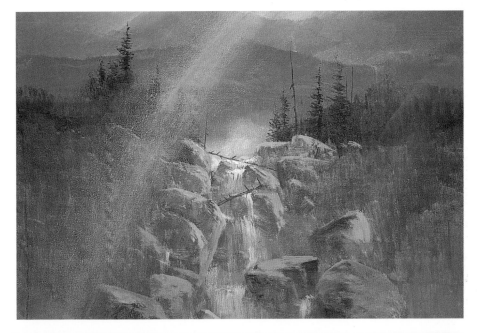

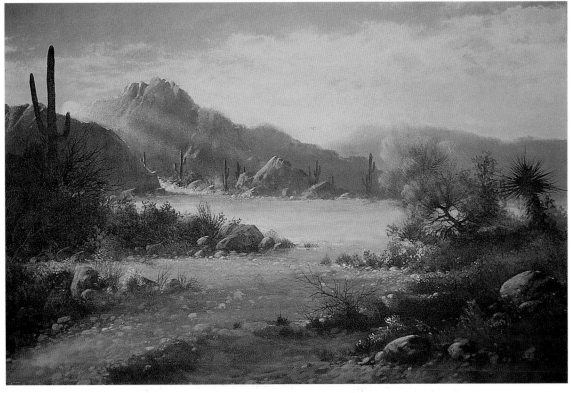

Creating Rocks Step by Step

How do you create a rock? First, know that this rock-painting technique applies to any type of rock or rock formation, color scheme and value system. So once you learn this technique, you can paint almost any rock project that you wish to tackle.

These are the basic steps for creating a good rock. In fact, I will make a small collection of rocks so you can see how to do a variety of rock sizes.

1 Block in the Basic Shapes
Take your no. 6 bristle brush and block in the basic shape of the rocks. Use a mixture of Burnt Sienna, Ultramarine Blue and purple. Add a touch of white to soften. Notice how rough and unorganized the rocks appear.

2 Refine the Rock Shapes
This step is simply to help you find a more accurate shape. We do this with an intermediate-value color by taking a dab of your rock color and adding white with a touch of orange. This will be a very subtle value change. Use a no. 6 or no. 4 bristle brush. Begin forming the shape of the rocks. Be careful not to paint out your background color. At this point you should have a fairly good three-dimensional form to all of the rocks.

3 Create Highlights

Now, we want to intensify the next value so that it almost looks like a highlight color. We do this by adding white and a touch of orange to the value color in step 2. Use a no. 4 flat sable brush or a no. 4 flat bristle brush and apply brushstrokes to the top and sides of the rocks to create form and unique designs within the rocks. The same rule applies: Do not cover up all of your underpainting color.

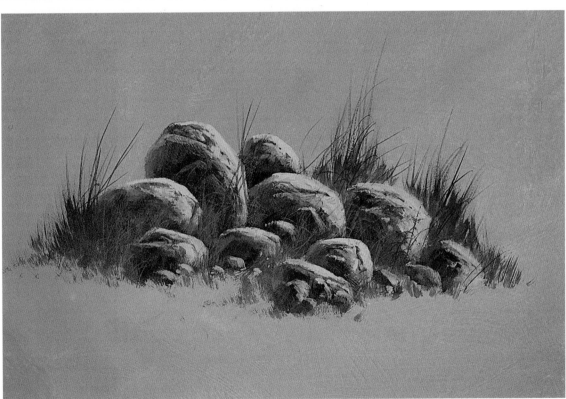

4 Add Final Details

Here, we add the final highlights and details such as cracks, holes and chips in the rocks. You can use any brush that you want to for this, but your smaller brushes will probably work best. Take the underpainting color for the cracks and then take the value color we used in step 3 and brighten it by adding white, yellow or orange for additional highlights. Have fun experimenting with the final details.

Painting Grass and Weeds

Even though grass and weeds may seem insignificant in the overall picture of a landscape painting, quite frankly they play one of the most important roles. Grass and weeds are like the icing on the cake. They pull the painting together. They can act as eye stoppers and final details, or they can play a major part of the composition. Look at a couple of examples of my finished work, and then I will take you step by step in creating good grasses and weeds.

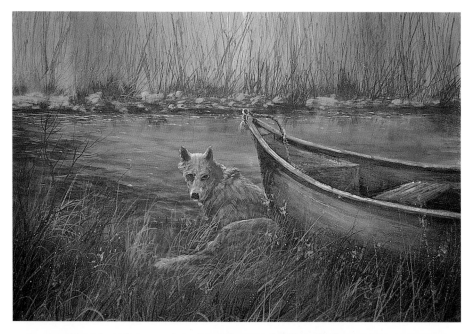

Keep in mind that there are many different types of weeds and grasses. My effort here is not to identify types of weeds but rather to show you basic techniques that you can apply to any type of weeds you wish to paint. Also, I am showing you only weeds for finishing and detailing your painting.

Notice in these examples how the weeds literally help pull your eye in toward the center of the painting. They also act as eye stoppers, and the taller weeds are a crucial part of the main composition. You must never be afraid to let the weeds do everything they are designed to do.

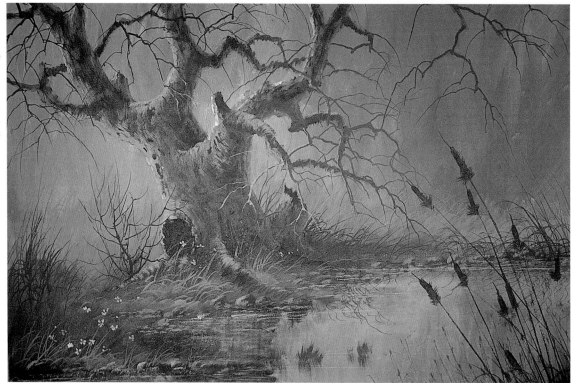

Creating Grass Step by Step

Look at a few basic techniques for creating good weeds. First of all, you will need a no. 10 bristle brush and your no. 4 script liner brush.

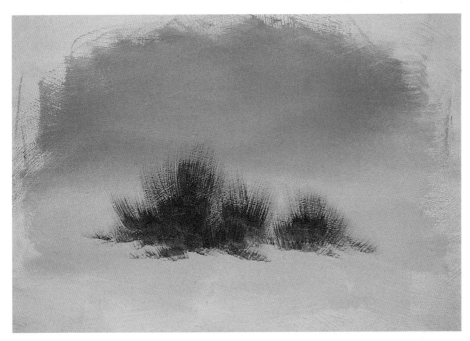

1 Paint Background Grass

The first step is to have a good background of shorter grass to act as a buffer between your underpainting and the taller weeds. Once your underpainting is dry, mix the appropriate color that works well with your color scheme and make it a value that is slightly darker than the underpainting. Take a no. 10 bristle brush and a drybrush technique using an upward motion to create a soft clump of background grass. Be sure the clump has good negative space and has an interesting shape.

2 Paint in Short and Tall Weeds

Using the same color, thin it down with plenty of water to form an inky mixture. Roll your no. 4 script liner in the mixture until it comes to a fine point and paint in the shorter weeds. Next, gradually add the taller weeds. Here again, negative space is critical, so do not be afraid to add plenty of weeds that bend and overlap each other. Of course, weeds can go in all directions. Only you can determine where you place the weeds and their intended use.

Note: When painting the weeds, always start from the bottom up, never from the top down.

3 Mix in Lighter Weeds

Here, you will take the same color used in step 2, but lighten the value by adding white, a touch of yellow or orange. Add the lighter weeds and mix them in among the darker weeds. You can continue making the mixture lighter if necessary to create more of a sunlit effect.

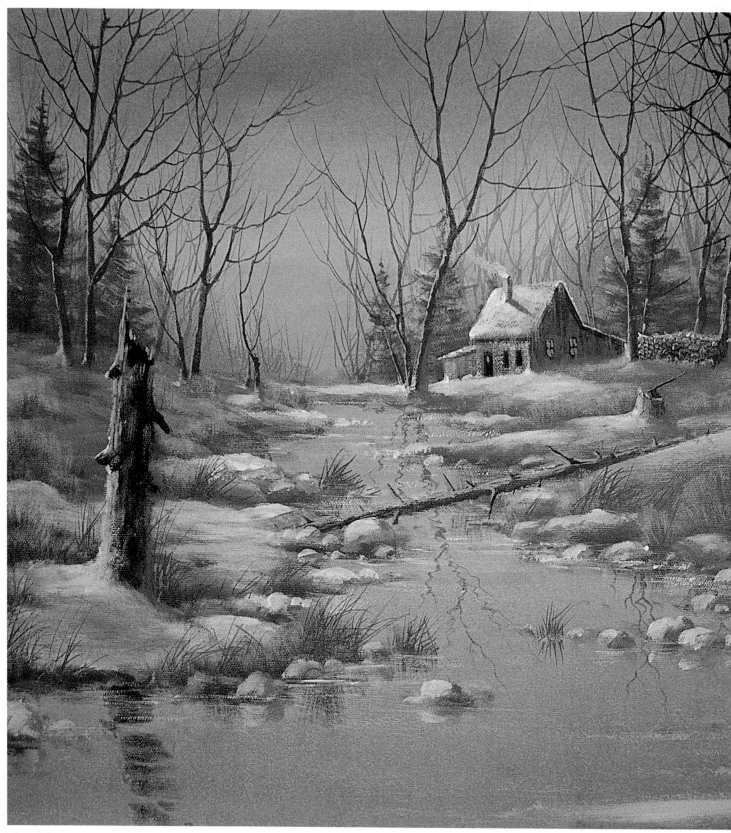

Winter Retreat
16" x 20" (41cm x 51cm)

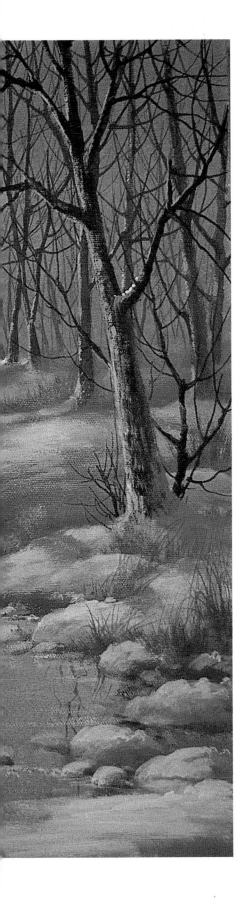

Winter Retreat

Wintertime—what a great season, especially when snow is the feature. Even though winter is my favorite season, and snow is one of my favorite things to paint, the key reason for doing this painting is to practice some of the techniques that we studied at the front of the book. For example, for those of you who are having a difficult time mastering the no. 4 script brush, this painting gives you plenty of opportunity to practice one of the most important components of a winter landscape: you guessed it, trees with no leaves. This is a great place to really work out the kinks in your tree-painting techniques. Here, we really concentrate on negative space, eye flow and overlapping of the limbs. This is a great place to practice brush pressure and getting your tree mixture to be the right consistency. This painting also shows you how to glaze in order to create a nice soft hazy effect. Of course, there are many other learning opportunities, as well. So, grab your brushes and settle in for a great painting experience.

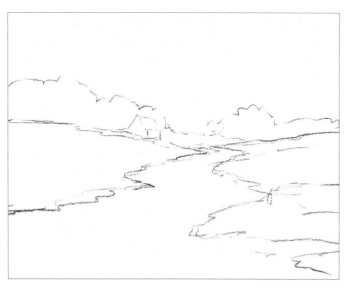

1 Create a Rough Sketch

With your soft vine charcoal, make a very loose and rough sketch of the basic ground formations.

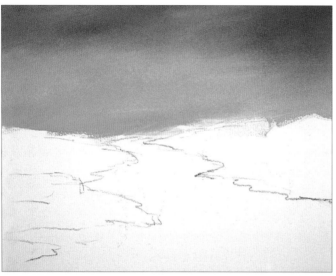

2 Underpaint Sky

For this step you will need your hake brush. The first thing to do here is to lightly wet the entire sky area, then apply a liberal coat of gesso; while the gesso is still wet, begin at the horizon and apply pure Cadmium Red Light. Cover the entire sky area until the whole sky takes on the medium pink tone; while this is still wet, beginning at the top, apply pure Ultramarine Blue and blend with a downward criss-cross stroke until the sky takes on a grayish tone. It will turn slightly purple. Don't blend too smoothly, or you will lose the nice brushstrokes that give the sky a little motion. Be sure to leave a nice pinkish glow at the base.

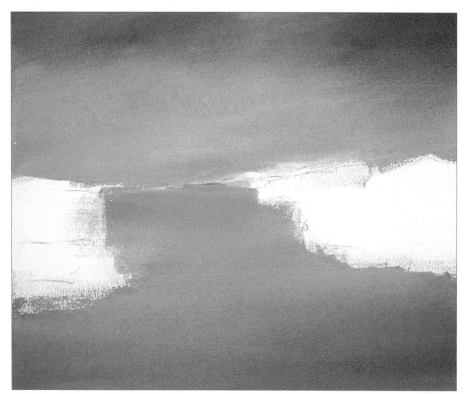

3 Underpaint Water

No surprise here! We paint the water the exact same way that we painted the sky; the only difference is we reverse the application. The dark area is at the bottom of the painting, and the light area is at the top. Notice how everything merges together at the horizon.

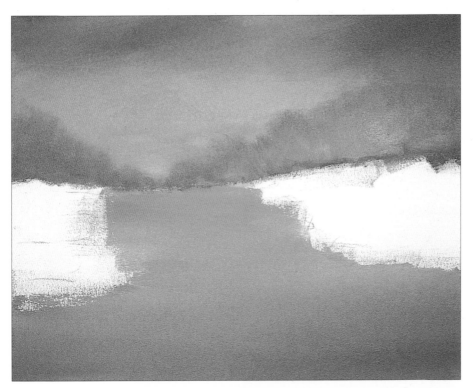

4 Add Soft Background Trees

This step is simple but important. Take your no. 10 bristle brush and mix Ultramarine Blue, a touch of Cadmium Red Light and whatever amount of white you need to create a value that is slightly darker than the sky. Now, with a dry-brush scumbling stroke, scrub in a soft background of distant trees. The key here is making sure that they fade out into the sky area with no hard edges. Be sure to give them interesting shapes.

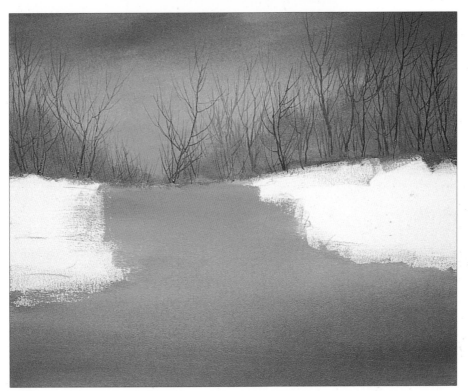

5 Paint Distant Dead Trees

Now for the step that everyone dreads: painting trees with your script brush! We have been through this drill before, so grab your script brush and mix a color that is slightly darker than the background trees. Be sure the mixture is very thin, very much like ink. Now, paint in these delicate distant trees all across the horizon. Notice, the wide variety of shapes, sizes and heights. If you don't remember how to use the script brush properly, refer to the front of the book for that technique.

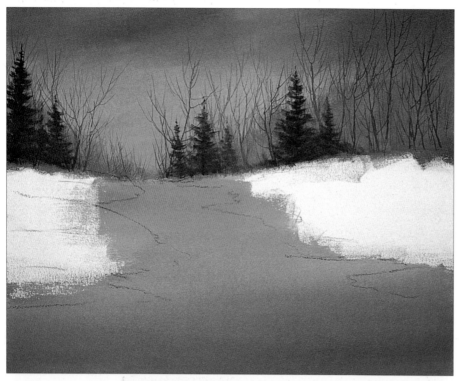

6 Add Background Cedars

Cedar trees are generally shorter and fatter and have branches that go more upward; therefore, they aren't as interesting as most pine trees. So, you have to use your artistic license to make them a little more interesting. First, take your no. 6 bristle brush and mix Hooker's Green, half as much purple, a touch of Burnt Sienna and whatever amount of white you need to create a value that is slightly darker than the background trees. Now, with a semi-dry brush stroke, scrub in your cedars so that they have good negative space around them as well as different heights.

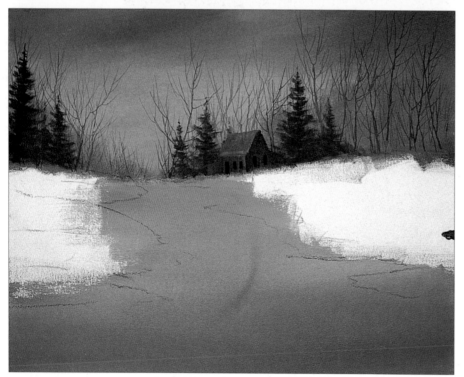

7 Underpaint Cabin

You can design your own cabin, house or barn, whatever you choose; but whatever you choose needs to be underpainted in soft gray tones. First, you might want to sketch it in with your charcoal. Now, use your no. 4 flat sable brush and mix Ultramarine Blue, a little Burnt Sienna, a touch of purple and enough white to create a value that fits that area of the painting. Block in the two sides, then add more blue and purple to the mixture and block in the roof. Darken the mixture and block in the doors and window.

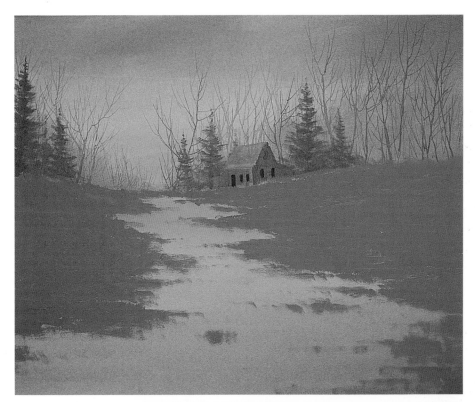

8 Underpaint Snow

Here, we need to mix a fairly large amount of color, so use your palette knife. Take gesso, half as much Ultramarine Blue, one-fourth as much Burnt Sienna and a small amount of purple; this should be a grayish purple. Now, all you do here is block in all of the snow area all the way to the water. Notice the irregular shapes along the water's edge; also notice that the edges of the snowdrifts on the water are horizontal, which makes the water look flat. Use your no. 10 bristle brush for this step.

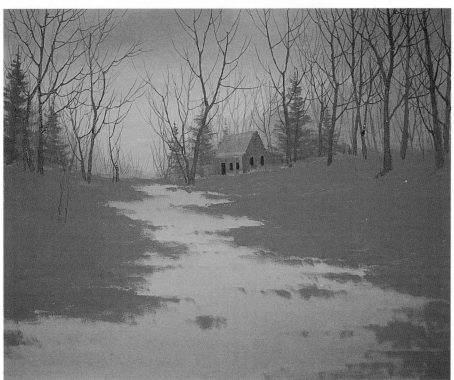

9 Underpaint Middle-Ground Trees

This step is one of the more critical ones. Composition is the real issue here. First, mix Ultramarine Blue and Burnt Sienna, with just enough white to change the value. This should be an intermediate value for the middle ground of this painting. Now, take your no. 4 flat sable and block in the main trunks of these trees; then thin the mixture and use your script brush to finish out the trees. Once again, be aware of the placement of each tree and use good negative space.

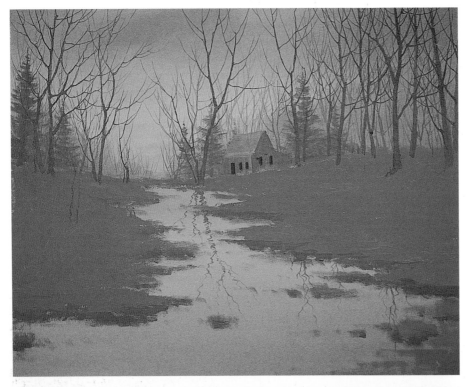

10 Darken Shoreline and Add Reflections

For this step, take the same color that you used in step 9 for the trees and lighten it slightly with a little white. Now, with your no. 6 bristle brush, scrub in a darker shoreline, then switch to the no. 4 flat sable and scrub in the reflections from any of the middle-ground trees that are close enough to the water to have a reflection.

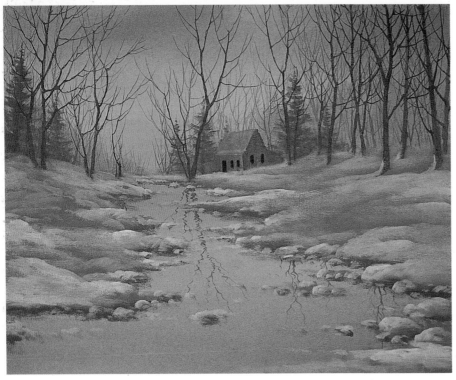

11 Highlight Snow, Phase 1

Now, let's premix a highlight color of white or gesso, plus a very small amount of orange to slightly tint the white. Take your no. 6 bristle brush and brush in the highlights on the snow and the snowdrifts on the water. The main purpose of this step is to locate the contour of the snow. Creating good eye flow is essential here. The final highlights will be done later. Be sure when you apply this highlight that you use a soft dry-brush stroke so that the edges are soft.

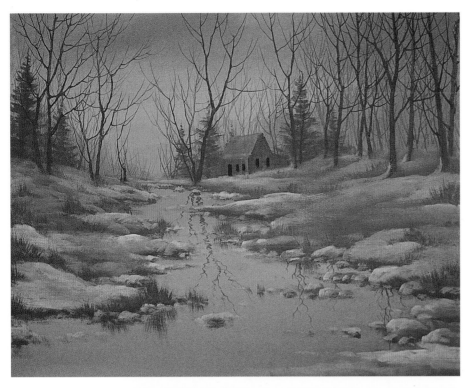

12 Underpaint Clumps of Grass

Now, mix Burnt Sienna with a very small amount of purple and a touch of Ultramarine Blue. You will need to add a touch of white to slightly soften this color. Then, in selected areas throughout the snow and along the water's edge, drybrush in clumps of grass using a vertical stroke. If you are not careful, you can get this too busy. So watch your negative space and overlap some of the clumps, and you will be OK.

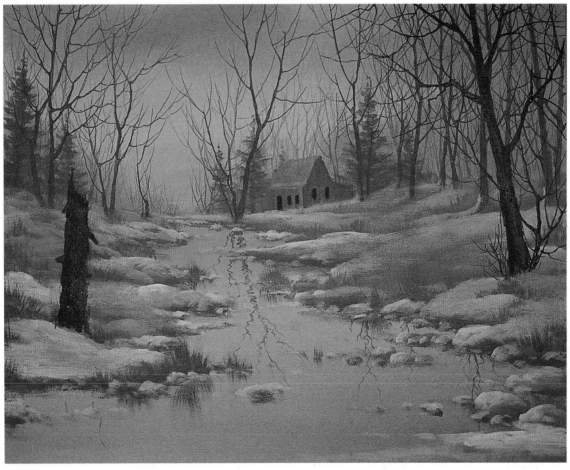

13 Underpaint Foreground Trees

Now that we are in the foreground, your values can be much darker. Let's mix Ultramarine Blue with an equal amount of Burnt Sienna. With your no. 4 flat bristle brush, block in the larger foreground trees and the stump, then thin the mixture down and use your script brush to add all of the smaller limbs.

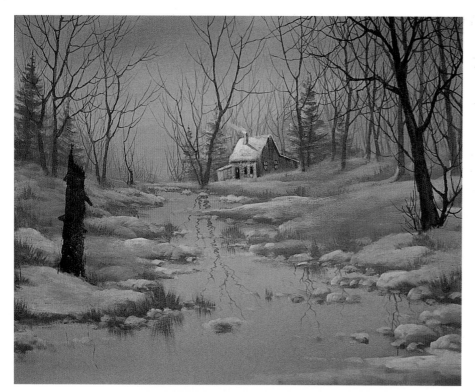

14 Detail Cabin and Cedar Trees

Because we want these objects to remain soft and distant, we don't want to overhighlight or detail. Take your no. 4 flat sable brush and mix white with a touch of orange to tint it, and block in the snow on the roof. Also, smudge a little snow on the cedar trees. Now, slightly soften the left side of the cabin; then, add the chimney, the shadow from the chimney, the smoke from the chimney and the light in the windows. Remember, no major details.

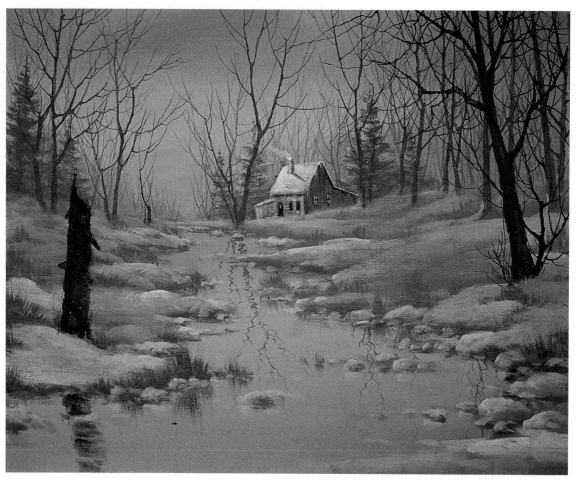

15 Final Reflections On Water

At this point, we need to add reflections from the foreground trees and clumps of grass and any other objects that are close enough to the water to be reflected. Be sure these reflections have soft blurred edges and are slightly lighter than the objects being reflected. Your no. 6 or no. 4 flat bristle brush would work best for this.

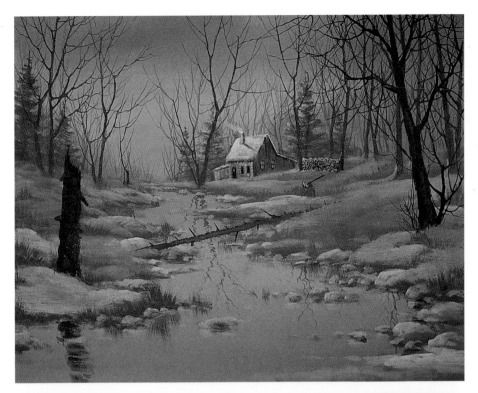

16 Add Miscellaneous Objects

This is a great time to add the objects to your painting that give it more character, such as the fallen logs, dead bushes or even some wildlife or people. For me, adding the woodpile and the chopping stump with the ax adds a hint of life to the painting; these are fairly simple objects to add. The main thing to remember is to keep these objects simple without too much detail.

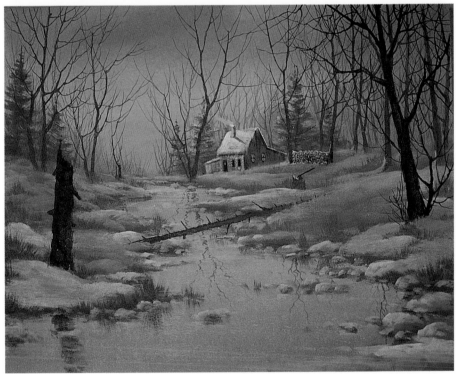

17 Glaze Water

This is a technique we have used before. Its main intent is to soften the water and give it a little more of a gloss or make it appear a bit wetter. First, lightly wet the water area, then create a glaze of water and gesso. Now, take your hake brush and load it evenly across the end, then lightly drag it across the surface of the water with a slight jiggle, which makes the water look slightly rippled. Repeat this step if you think it is necessary.

18 Highlight Trees and Grass

This is the step where we add the clean final highlights that give your painting a crisp refined look. For example, you can add thin white lines along the water's edge, also on the edge of your trees; notice the bright whitish orange sunlight. Also, use this same highlight and drybrush some highlights on the tops of the clumps of grass. Now, search through your painting for areas where more light or minor details would finish out the overall composition and brightness in the painting.

19 Highlight Snow, Phase 2

This step really makes your snow come alive. All you need here is your no. 4 flat bristle brush. Mix white or gesso and a little touch of orange to tint it, then simply drybrush in some strong bright light on the raised areas of your snowdrifts. Now, drift the snow up against the clumps of grass and tree trunks, which helps to settle them down in the snow.

20 Add Cast Shadows

Here, we need to add the cast shadows from the trees and other objects. The color we need for this is a mixture of white, with a touch of purple, Ultramarine Blue and a little Burnt Sienna. This shadow should be a purplish gray. Now with your no. 4 flat bristle brush, scrub in the shadows, being sure that they follow the contour of the snowdrifts and that they have soft edges. Another important thing here is to be sure that the value is correct. If the shadows are too dark, they will jump off the canvas and overwhelm your painting.

As an option, if you think your painting needs to be softened, or only parts of it such as the background trees, then just mix a glaze of water and a little white. Now, with your hake brush, glaze the area that you want to soften, then take a paper towel to wipe off any areas that you overglazed.

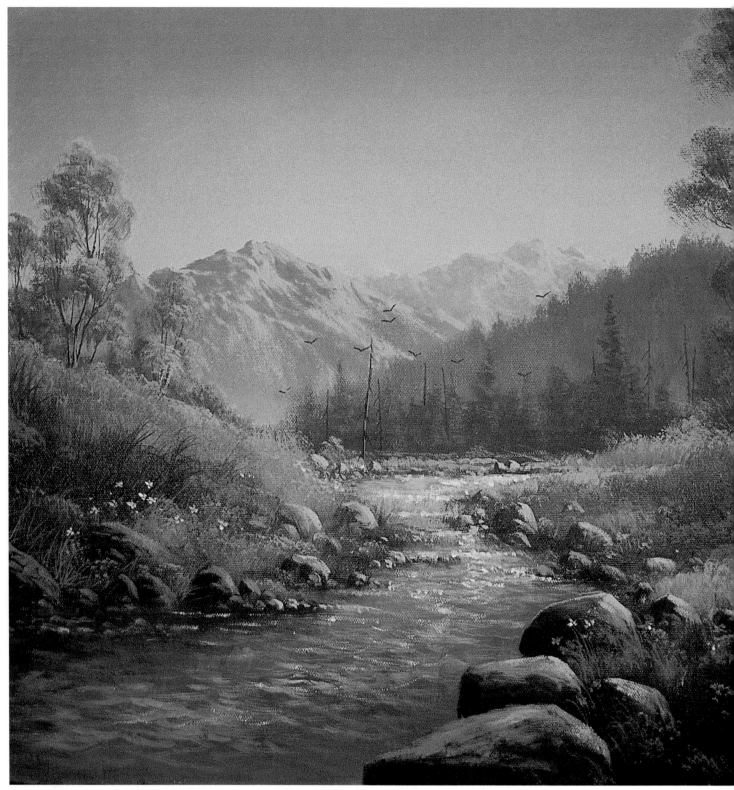

Summer Dreams
16" x 20" (41cm x 51cm)

Summer Dreams

In this fast-paced push-button world, how would you like to find a place like this, where you can go and leave all of your cares behind you for a while? The great thing about being an artist is that you can pick up a paintbrush and create your favorite place without ever leaving your studio. For me, nothing is more peaceful than a cool mountain setting with a running stream or babbling brook. In fact, the point that I want to get across in this painting is how to create running or rippled water. In the technique section at the beginning of the book we looked at this type of water. Now, you get a chance to apply some of these techniques in a completed painting; **Summer Dreams** *helps you see how to put it all together. This painting also offers many other practical learning opportunities; things like rocks, live trees, distant mountains and grass will help you expand your artistic library of techniques and practical applications. Keep in mind that there are many different variations of a painting like this, so don't be afraid to experiment. So let's get started. I know you will enjoy this one.*

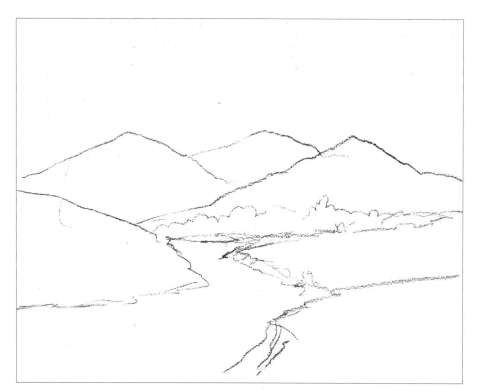

1 Create Basic Sketch

As is usually the case, take your soft vine charcoal and make a rough sketch of the basic composition.

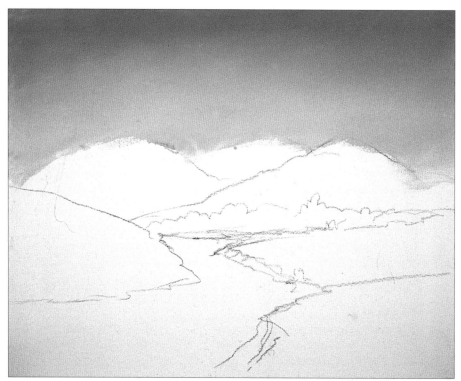

2 Underpaint Sky

For this painting, we want a clean, clear, bluish gray sky with a soft horizon. We begin by slightly wetting the sky area, and then we apply a liberal coat of gesso; while the gesso is still wet, starting at the horizon, take Alizarin Crimson and go over the entire sky until it becomes a light soft pink tone. While this is still wet, starting at the top of the sky, take Ultramarine Blue and a touch of Burnt Sienna. Blend these colors across the top of the sky and then down, until you create a nice soft bluish gray with a soft pinkish horizon.

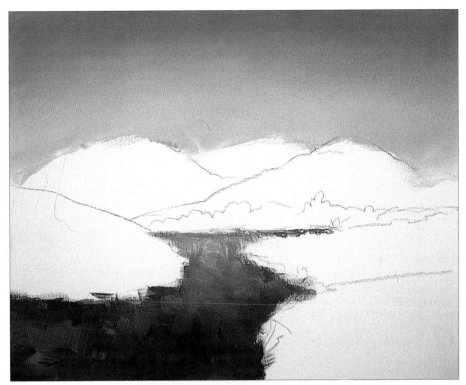

3 Underpaint Water

Since this is running water, it doesn't have to be a smooth application of color; in fact, you can have a lot of fun with this underpainting. Take your no. 10 bristle brush and a combination of the following colors: Ultramarine Blue, small amounts of Burnt Sienna, Dioxazine Purple and white. Now, using short choppy horizontal strokes, apply these colors and mix them on the canvas, not on your palette. The important thing here is to be sure that your canvas is well covered; also, you don't want to overblend the colors to a smooth texture. It's important to keep your strokes loose and free to suggest movement.

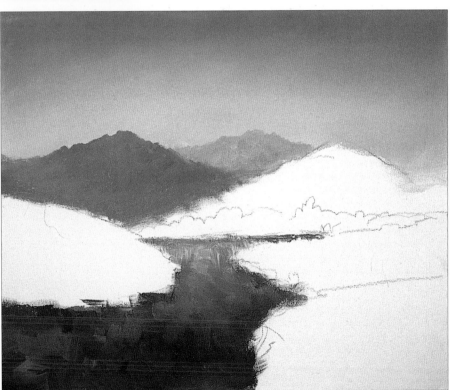

4 Underpaint Background Mountains

For this step, we need to mix a soft distant gray tone. Start with gesso and a touch of Ultramarine Blue, Burnt Sienna and a touch of purple; this should be a light purplish gray. The value is slightly darker than the sky. Now take your no. 6 bristle brush and block in the most distant mountain first, then slightly darken the mixture and block in the second layer of mountains.

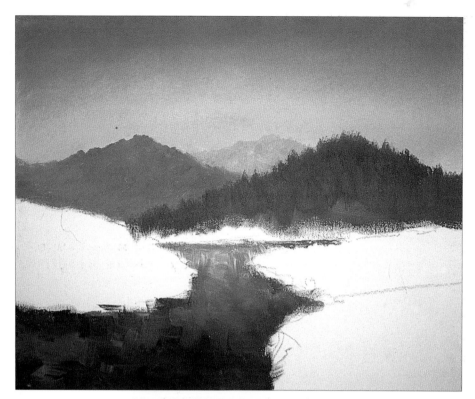

5 Underpaint Tree-Covered Hills

Take the mixture you used in step 4 for the second mountain range and darken it slightly, then add a small amount of Hooker's Green to create a grayish green. Now, take your no. 10 bristle brush and use a vertical dry-brush stroke and cover the entire area. The main thing to remember here is to be sure that the canvas is covered completely. Also, notice the treelike shapes along the top of the mountain.

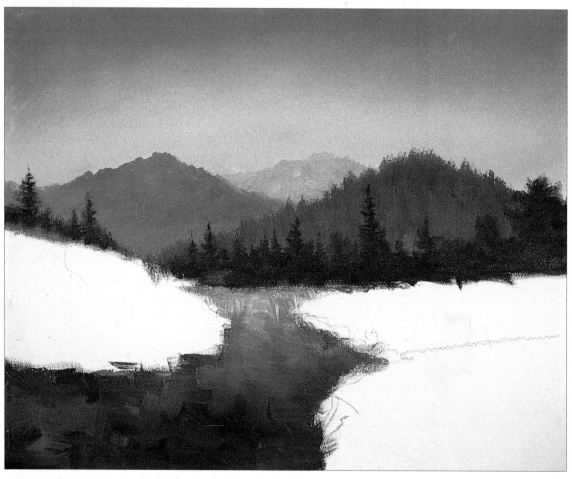

6 Paint Middle-Ground Trees

This is a short but important step. Take the mixture you used in step 5 and darken it slightly with a little more Hooker's Green and a touch of purple. Now, with your no. 6 bristle brush, paint in the basic shape of the trees; you could have a combination of pine, cedar and regular trees.

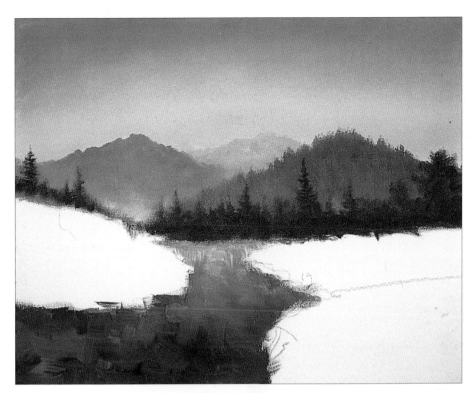

7 Mist Base of Mountain

Now, we get to use a specialty technique—mist. Take a little bit of gesso and a touch of Ultramarine Blue and Dioxazine Purple. Add enough water to make it slightly creamy. Now, with your no. 6 or no. 10 bristle brush, using a dry-brush circular motion and starting at the base of the mountains, blend upward until the mist fades away.

Note: Be sure the mountain range is completely dry before you begin.

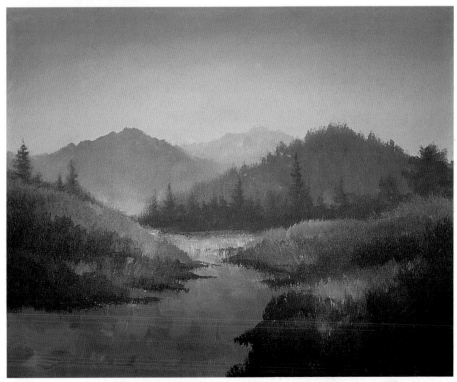

8 Underpaint Middle-Ground and Foreground Grass

This step is going to require a lot of loose Impressionistic strokes. This will be done with your no. 10 bristle brush. Beginning at the base of the mountains, apply Thalo Yellow-Green, touches of orange and maybe a little yellow. The paint must go on fairly thick, with very loose irregular strokes that are mostly vertical, and as you come forward, add Hooker's Green, Burnt Sienna, purple and maybe a little orange here and there. Notice the values become darker and darker as you come forward. Repeat this on each side of the river.

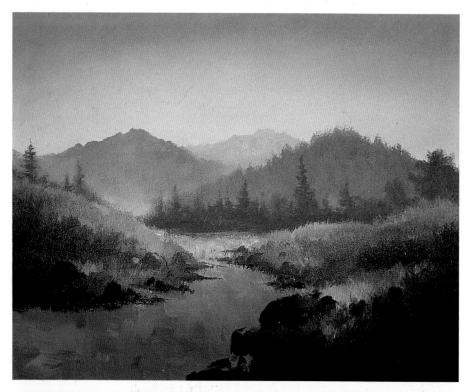

9 Underpaint Rocks

We need to add rocks along the water's edge. Mix on your palette some Ultramarine Blue, Burnt Sienna and a touch of purple with a little white. Now, take your no. 6 bristle brush and simply block in the main shape and location of the rocks. Be sure that you have good compositional balance and negative space.

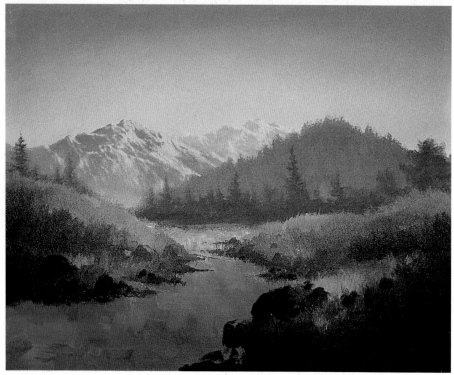

10 Highlight Mountains

Now, we will highlight both mountain ranges. You will need your no. 4 flat sable and a mixture of white with a touch of yellow and orange. The sunlight will be coming in from the right side, so drybrush highlights using a choppy broken stroke, creating interesting pockets of negative space. Now, add a little more yellow and orange to the mixture and highlight the second mountain range.

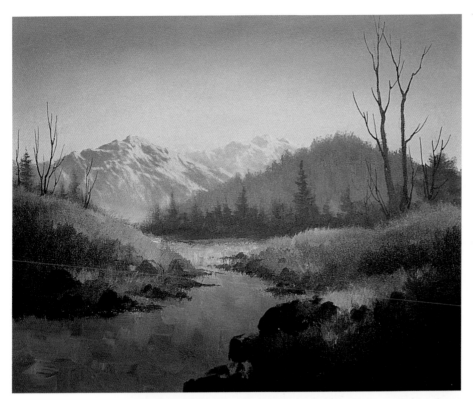

11 Underpaint Large Middle-Ground Trees

The first thing you need to do here is create a good skeleton of the tree. I suggest you use Burnt Sienna and Ultramarine Blue, with a little white to create a middle-tone gray. Now, with your no. 4 flat sable brush, block in the main trunk and intermediate limbs. Thin the mixture with water, and take your script brush and add a few smaller limbs. No need to add any tiny limbs to finish the tree; we add them later after we finish the leaves.

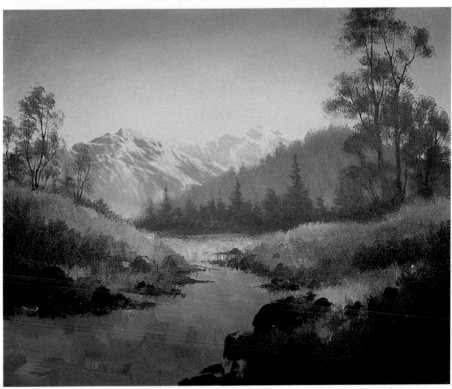

12 Leaf Middle-Ground Trees

Now, let's mix Hooker's Green, about one-fourth as much purple and a little white to create a nice soft greenish gray. Now, take your no. 10 bristle brush and dab in the leaves, gradually forming the main shape. You might add miscellaneous smaller trees or bushes at the base of the tree and on the other side of the river.

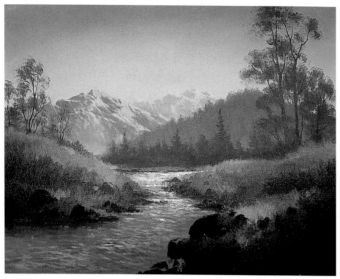

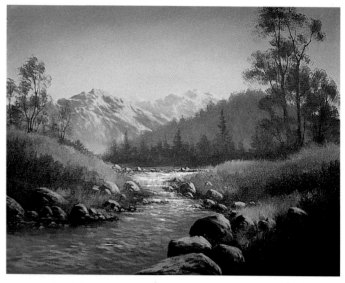

13 Detail Water

We want to darken the shoreline. With a mixture of Burnt Sienna and Ultramarine Blue, take your no. 6 bristle brush and smudge in a darker edge. It's important to lighten the value as you recede into the distance. Also, as you add the shoreline, be sure to reflect the darker value into the water, kind of like a reflection. Now, take pure white with your no. 4 flat sable brush, make it creamy, and add ripples and movement to the water; these are horizontal choppy concave strokes. Notice the water is more rippled at the back of the river and it becomes calmer as you move forward.

14 Highlight Rocks

Now, we want to mix white, a touch of orange and a little blue to gray it. With your no. 6 or no. 4 flat bristle brush, apply the highlight to the top right side of each of the rocks. You can also add a few highlights to suggest pebbles along the shoreline. Once you have the basic rocks highlighted, you can brighten the mixture and put an accent on the rocks to make them stand out a little more. Brighten the mixture with a little more white, yellow and orange.

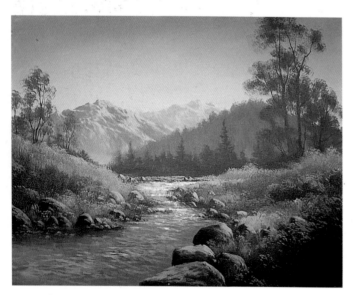

15 Highlight Grass

Now here, you have to be fairly creative. We are going to add miscellaneous highlights, flowers and other colors to give the painting a late summer afternoon glow. You will mainly use your no. 6 and no. 10 bristle brushes. It's really sort of hard to explain what to do here, but I'll do my best. The key is to scatter complementary colors to accent the painting. You can add more light to suggest sunlight and add more miscellaneous flowers, as well. The range of colors can be from yellows, oranges, reds, pinks, purples and even light blues. What I normally do is take one of my brushes and dab in the various colors, highlights and flowers throughout the painting, making sure that it has good color balance. A good habit to get into here is to stand back about 5' or 6' (2m) after every few strokes so you can better check your progress and see how your painting comes together.

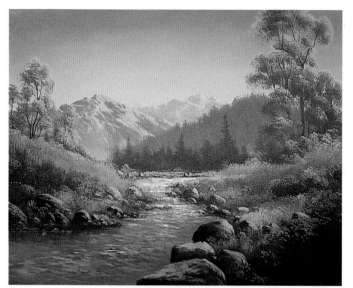

16 Highlight Large Tree and Bushes

This step requires careful planning. We will apply two highlights to give the trees their form. You will need your no. 10 bristle brush for the larger tree and the no. 6 bristle for the smaller bushes. The primary color will be a mixture of Thalo Yellow-Green and a little bit of orange; you may add a touch of white and/or yellow if you choose. Now, take your brush and dab the highlights on the large tree, being very careful not to cover up too much of the underpainting color. After applying this first layer of highlight, lighten the mixture with a little more white and yellow, and apply this final highlight to give your trees more of a sunlit effect. Don't hesitate to change the color for some of the bushes.

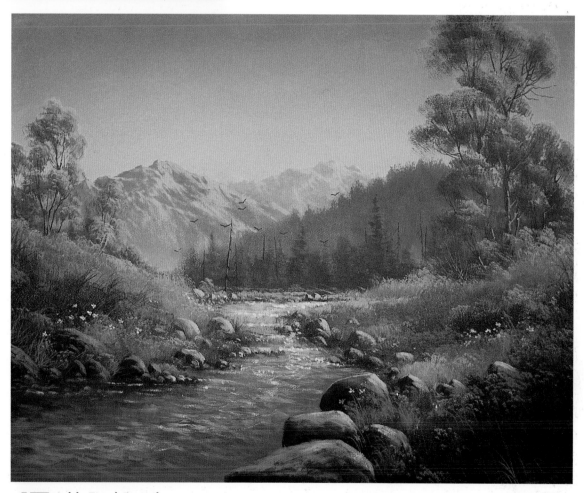

17 Add Final Details

This is where you will add the final things that will give your painting the personality you would like it to have. For myself, I added some tall weeds, additional flowers, highlights and birds. I even added extra color in the water to help tie it in better to the rest of the painting. Remember, a little distance will help you see the painting from a different perspective, and you can make better decisions about final details. As an option, add more mist. Refer to step 7 to refresh your memory on how to do this.

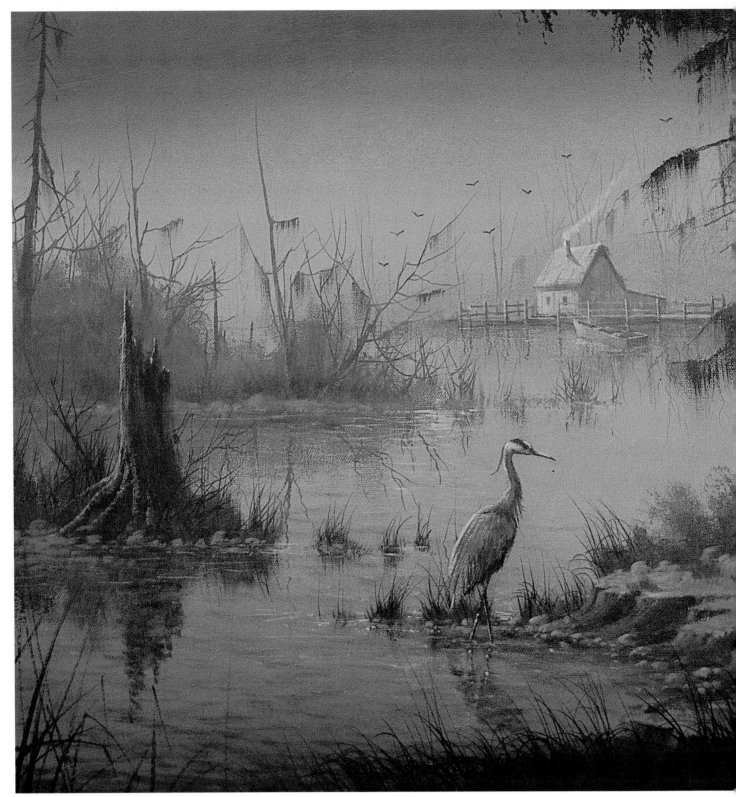

Swamp Fisherman
16" x 20" (41cm x 51cm)

Swamp Fisherman

I could not resist using this piece as an instructional painting; there's just too much good material in it. In fact, I taught this painting in one of my workshops in Florida and it was a great success, so I thought you would enjoy doing it, as well. What makes this painting so different is its unique color scheme, and even though that was not the main intent of this painting, at least you get to see what an important part a color scheme plays in creating a great atmosphere. The main purpose for this study painting is to practice one of the techniques at the front of the book: calm water. As simple as it may seem, painting calm water can be even more challenging than moving or rippled water. The real problem is getting the reflections to have the proper color, value and softness; in moving water, those things are not such an issue, but in calm water, if the reflections are not done correctly, they will overpower the painting and be in direct competition with the main focal point. Hopefully, this painting will help unravel some of these problems and help build your confidence in painting calm water.

1 Make Basic Sketch

This step is really not that difficult. All you need is a straight line across the canvas, about one-third of the way down from the top of the canvas.

2 Underpaint Sky

This unique color scheme is a lot of fun to work with. The procedure is the same as usual. Lightly wet the sky with water, then add a liberal coat of gesso over the entire sky with your hake brush. While the gesso is still wet, start at the horizon and apply orange with a touch of yellow, blending it all the way to the top. Now, take Ultramarine Blue and a touch of Burnt Sienna; start at the top and blend down until you have faded these colors out near the horizon. You should mix these colors directly on the canvas, not on your palette.

3 Underpaint Water

To paint the water, I am going to ask you to do something a little different here. Turn your painting upside down and repeat the same procedure as in step 2 for the sky. The main thing here is to be sure that the sky and the water are blended at the horizon so that there is no hard edge.

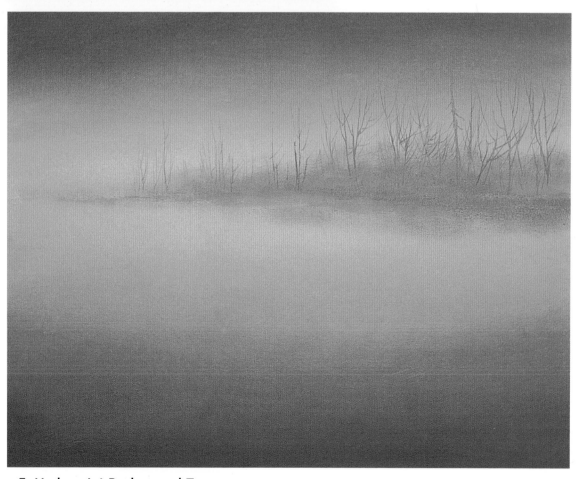

4 Underpaint Background Trees

This first layer of trees is very distant and very soft. Create a mixture of white, Ultramarine Blue, a touch of Burnt Sienna and a touch of purple. Now, with your no. 6 bristle brush, scrub in the first layer of distant trees, keeping them very dry and very soft. Now, thin the mixture with water, and take your script brush and paint in a nice collection of distant dead trees.

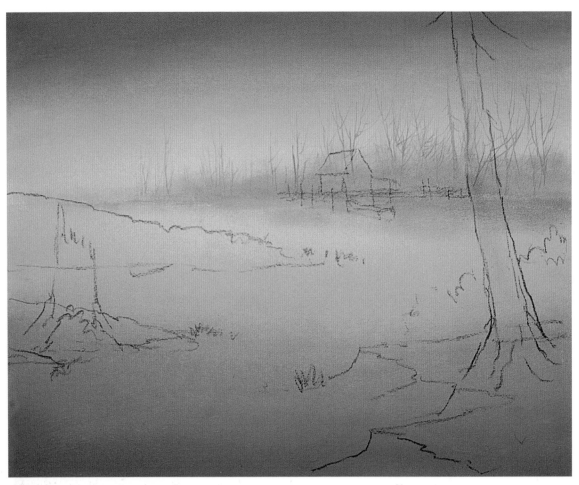

5 Sketch in Composition

Now that the background is underpainted, take your charcoal and make a rough sketch of the main components of the composition.

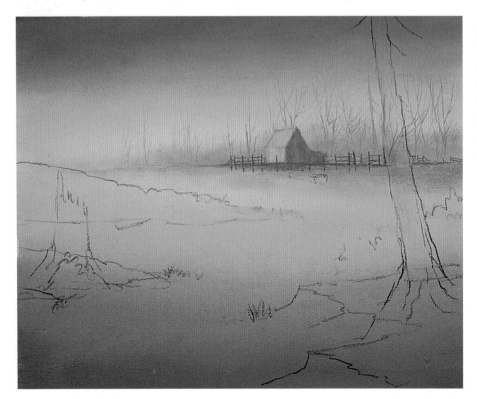

6 Underpaint Shack and Boat Dock

Mix a value of color that is slightly darker than the background trees; this consists of white, with a touch of Ultramarine Blue, Burnt Sienna and purple. Take your no. 4 flat sable brush and block in the shadowed side of the shack; also, block in the shadow under the boat dock and the pier posts. Now, lighten the mixture with a good bit of white and block in the light side of the shack.

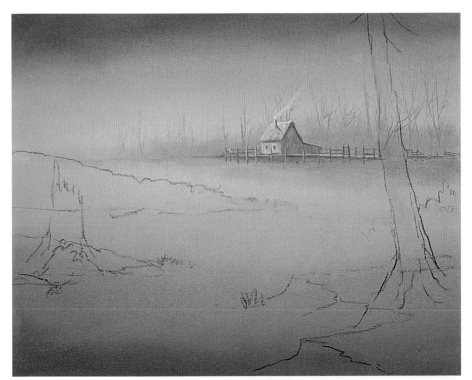

7 Detail Shack

Take the dark value that we used for the shadowed side of the shack and add a little purple to it. Now, with your no. 4 round sable brush, paint in the overhang shadows from the roof, the chimney and its shadow, and block in the windows. Take pure yellow and orange, with a little white, and paint in the light in the windows. You can take a little white with your finger and smudge in the smoke from the chimney. If you want to, go ahead and detail the dock, or save it for the final step of miscellaneous details.

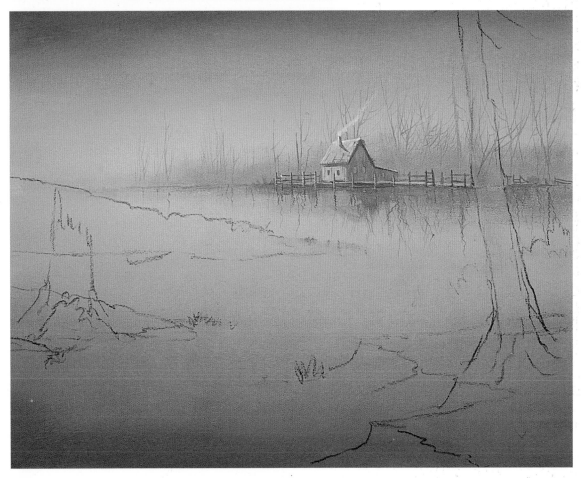

8 Add Reflections From Background Trees

This is a short but necessary step. Take the background tree color and add a little white to it. Now, take your no. 6 bristle brush and scrub in the reflections in the water, then take your no. 4 round sable and carefully paint in the dead-tree reflections. Even though most of the shack reflection will be covered later, it's a good idea to paint it in, just in case some of it shows.

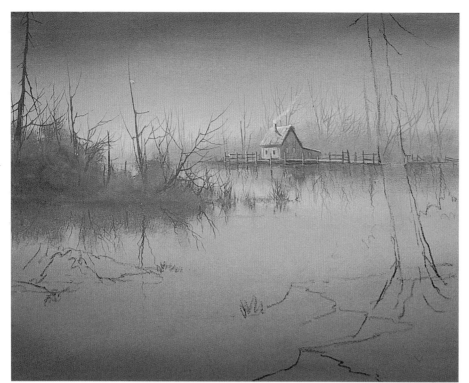

9 Underpaint Middle-Ground Bushes and Trees

This step requires a mixture of Burnt Sienna, a touch of purple, white, Ultramarine Blue and a little orange. You should experiment with the mixture until it fits your color scheme. Now, take your no. 10 bristle brush and scrub in the middle-ground bushes, then thin the mixture and take your no. 4 script brush, and paint in the dead trees and smaller dead bushes. This is a good time to take your no. 6 bristle brush and scrub in the reflections from these middle-ground bushes and trees. You should add a little white to the mixture to soften it before adding the reflections.

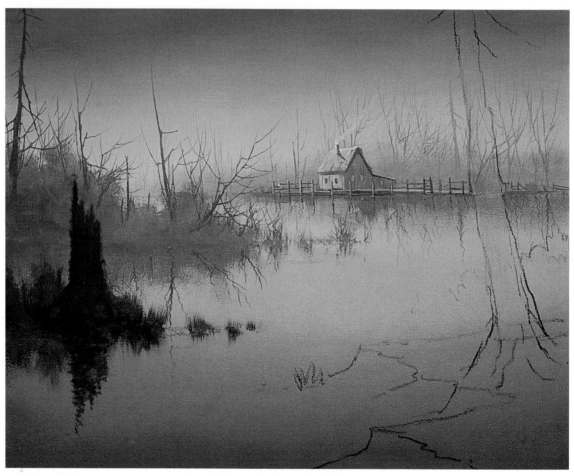

10 Underpaint Stump and Middle Foreground Bushes

Just darken the mixture used in step 9 by eliminating some of the white, then take your no. 4 bristle brush and block in the stump and the bushes on the left side of the painting. It's important to go ahead and paint in the reflections from the stump and the clumps of grass, so lighten the mixture slightly and scrub in the reflections.

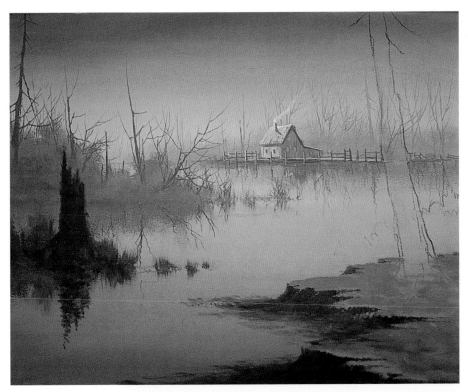

11 Underpaint Foreground Bank and Dirt

For this step, mix Burnt Sienna with a touch of Ultramarine Blue, Dioxazine Purple and a little white to change the value. Now, take your no. 6 bristle brush and, with a comma stroke, block in the bank and gradually fade it into the water. Notice how irregular the edge of the bank is. Now, slightly lighten the mixture with a little white and, using choppy horizontal strokes, block in the top of the bank. You can lighten the mixture with white and a touch of orange and add a few choppy brushstrokes to give the dirt a little more interest.

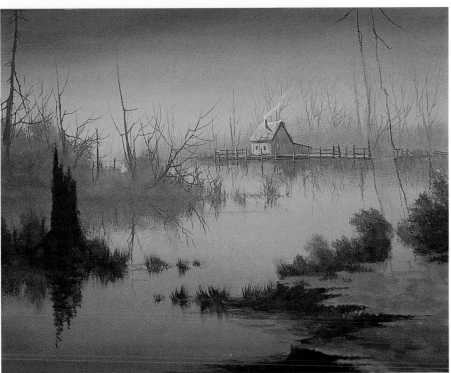

12 Add Middle-Ground Clumps of Grass

Here, you want to create a mixture of Burnt Sienna, Ultramarine Blue, and a touch of purple and white. This is a fairly dark value, so don't add too much white. Now, with your no. 6 bristle brush, drybrush in the clumps of grass and small bushes along the bank and in the back of the dirt area. Keep in mind that the clumps of grass we put in the water need to be reflected; do this at the same time that you add the clumps. The reflection value is slightly lighter, so add just a touch of white.

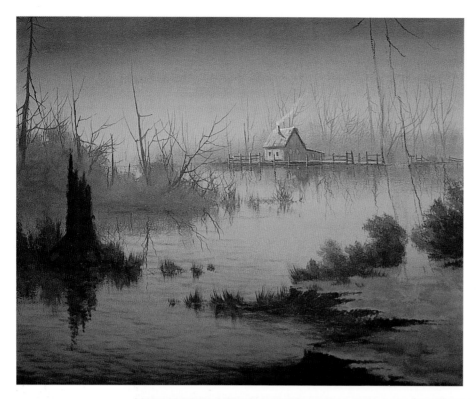

13 Add Ripples in Water

What we do here is mix Ultramarine Blue with a little Burnt Sienna and a small amount of white; this should be a deep bluish gray mixture. Add just enough water to make it creamy. Now, take your no. 4 flat bristle brush and, beginning at the bottom of the water, work your way upward, using a series of short choppy horizontal strokes and gradually decreasing your pressure as you go, until this value fades into the lighter value.

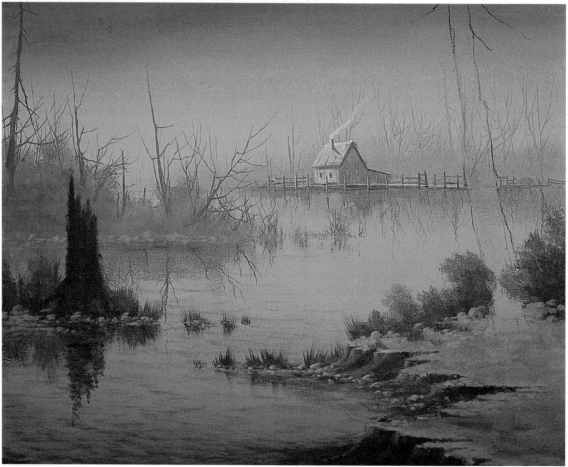

14 Add Rocks and Pebbles

For this step, you want to mix white with a touch of orange. If this value is too bright, don't hesitate to add just a touch of blue to slightly tone it down. Now, take your no. 4 flat sable brush and paint small rocks and pebbles along the shoreline and on top of the dirt bank. Be sure you put in enough rocks and pebbles to really tie the shoreline to the water.

15 Block In Large Tree, Add Hanging Moss

Mix Burnt Sienna and Ultramarine Blue and, with your no. 4 flat bristle brush, block in the main structure of the large tree. Now, thin the mixture to an ink-like consistency, take your script brush, and add all the smaller limbs. It is especially important that you have good negative space in, around and through these limbs. This is a good time to add the moss, and it's really quite simple. Take this same mixture without much water, and your no. 6 bristle brush, and drybrush downward from certain limbs and across the top of the canvas. Add moss on the middle-ground trees, but first, lighten the mixture to the proper value.

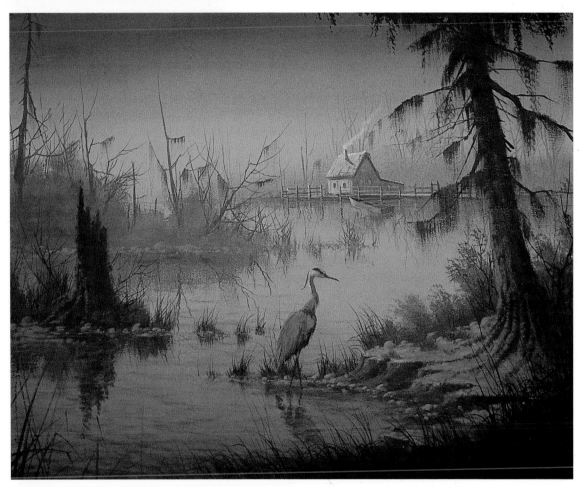

16 Add Miscellaneous Objects and Details

The main things we are going to put in now are the rowboat in the background, the blue heron standing in the water, and the taller weeds in the foreground. It takes one main mixture to do all of these objects; the only difference is that each of these objects will have a different value. The mixture is Burnt Sienna, Ultramarine Blue and a touch of purple. Now, for the foreground weeds, smudge in a base background, then thin the mixture and, with your no. 4 script brush, paint in the taller weeds. As for the heron and the boat, sketch them first with your charcoal. Now, change the value of the mixture with a little white, and underpaint both objects with your no. 4 flat and/or no. 4 round sable. Using your script brush, add the small dead bushes throughout the painting.

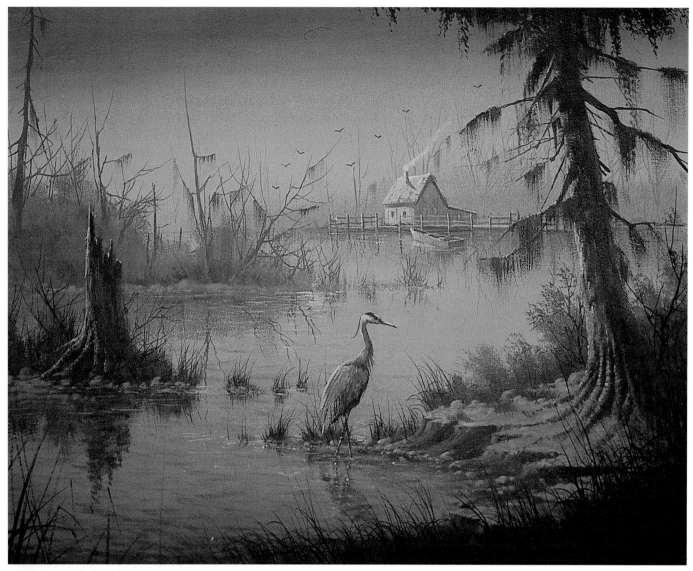

17 Create Final Highlights

This is the step that truly gives the painting its light and life. First, mix white with a touch of yellow and orange. You will probably use two brushes, the no. 4 round and flat sables. Now, it's a matter of applying these highlights in the right areas, such as on the inside edge of your trees and the sunlit ripples on the water. Then, of course, you need to highlight the heron and the rowboat, and gently scrub in their reflections. When you apply these highlights, be sure that they are fairly opaque; this will assure good clean light. However, when you highlight the heron, you will use more of a dry-brush stroke to give a slight impression of feathers.

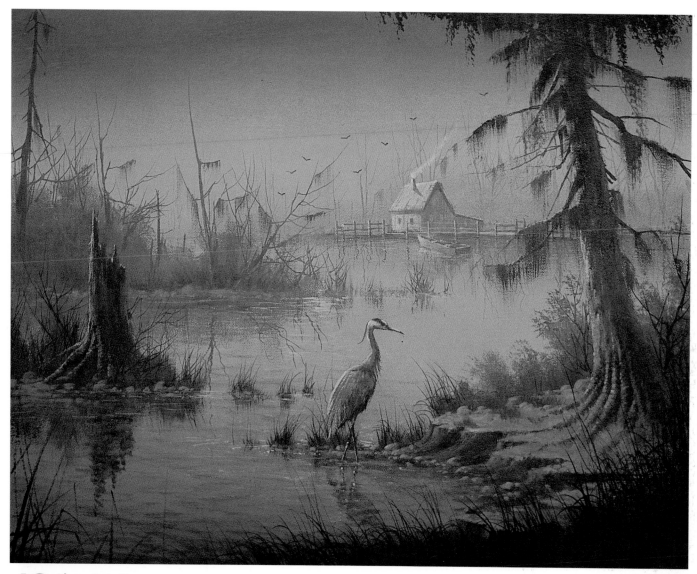

18 Glaze Painting

This is really an optional step, one we have done before. If you are satisfied with the overall softness of the painting, you can avoid this step; however, if you need to soften your painting, a glaze works great. For this painting, a glaze of water, a little white and a touch of orange works best. Remember, this is a very thin transparent mixture. Now, take your hake brush and apply the glaze to the area you want to soften. Use a damp paper towel to take off any excess or unwanted glaze. Refer to page 20 for a refresher on how to glaze.

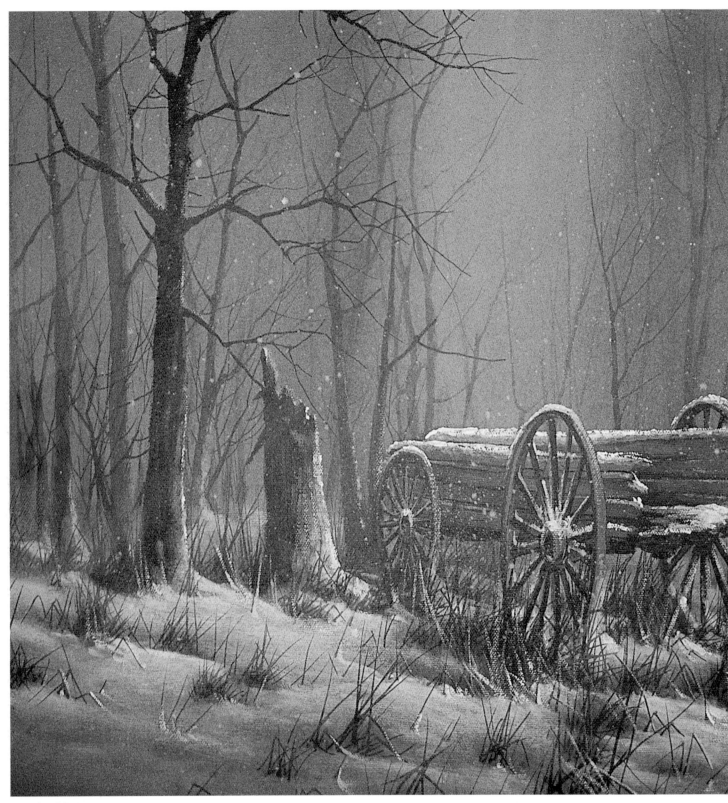

Reminder of the Past
16" x 20" (41cm x 51cm)

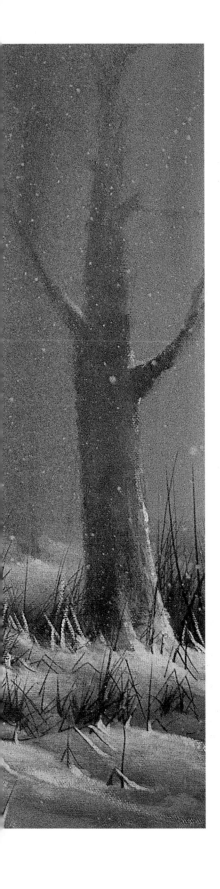

Reminder of the Past

As you know by now, I love to paint snow. Even though we have already done one snow scene, I thought it would be appropriate to do one in a setting where we could again practice the technique of glazing to suggest a foggy, hazy or misty effect. In a painting like this one, it is absolutely necessary to know how to create a good misty effect so that the snowy atmosphere we want to create will blend in nicely with the rest of the composition and color scheme. Not only does the mist help with the snowy effect, but it also softens the painting and, depending on what color glaze you use, will also help make it a cool or warm atmosphere. This painting also gives you another chance to practice painting tree limbs with your no. 4 script brush. There are also some good value changes in the trees to help create a little depth. So, you will learn a lot in this painting, and not only that, but it is just simply a fun painting to do, especially the old weathered wagon. This could be one of your favorites. Good luck!

1 Underpaint Background

For this step, you need your hake brush. We will block in about the top two-thirds of the canvas; this will be a multicolored background, with a predominately gray overtone. Begin at either side of the painting by applying gesso, with enough water to keep it creamy. As you apply the gesso, add these following colors: Ultramarine Blue, Burnt Sienna, Dioxazine Purple, touches of red and, believe it or not, a little Hooker's Green. Use long vertical strokes that overlap each other, adding the above colors as you go. Do not blend these colors to a solid gray tone. You still want to see hints of each of the colors used, plus you want to see some of the brushstrokes.

2 Underpaint Foreground Snow

What we do here is mix on our palette the underpainting color, which consists of white, half as much Ultramarine Blue, and a touch of Burnt Sienna and Dioxazine Purple. This should be a fairly dark bluish gray; if it leans to the purple side, that's OK. Now, take your no. 10 bristle brush and paint the entire foreground. Be sure the canvas is well covered and that the place where the snow underpainting and background meet has a soft edge.

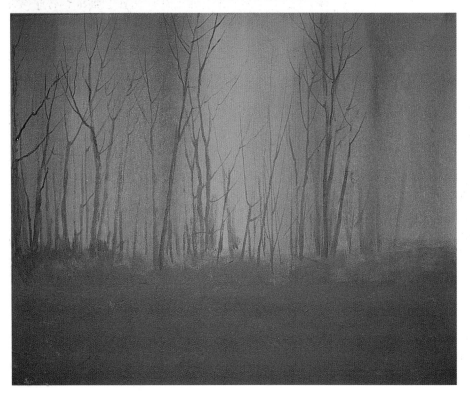

3 Paint First Layer of Background Trees

To create the layers of depth in this painting, we will need several value changes in the trees. The way we do this is to take the underpainting color for the snow and add enough white to change the value so that it is slightly darker than the background; make it fairly creamy. Now, take your no. 4 round sable and your no. 4 script brush and paint in the first layer of trees. Notice how some of them fade off into the background; this creates the suggestion of mist or haze.

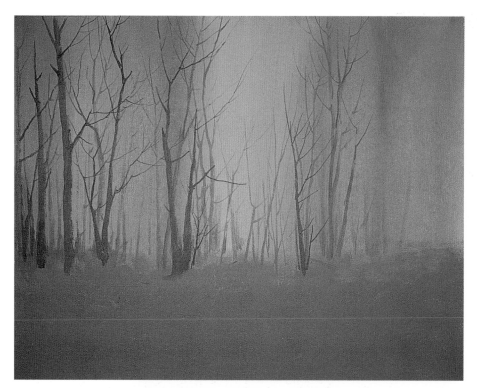

4 Create Second Layer of Background Trees

This step is almost identical to step 3, except the value is a little darker and the trees have a little bit more definite form. You can use your no. 4 round or flat sable and/or your no. 4 script brush. This step will bring you all the way to the large trees on the left. You should have a good variety of values and shapes to your trees at this stage. Notice, however, that there are not many trees on the right side; this step is left out intentionally.

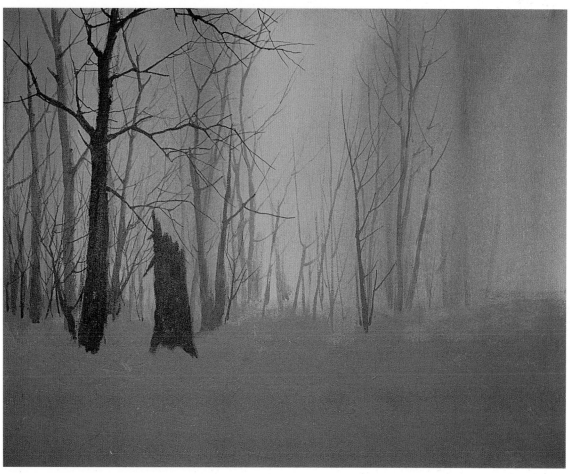

5 Underpaint Large Tree and Stump

You may want to take your charcoal and sketch in the tree and stump on the left. The large tree on the right we will do later. Now, take a mixture of Ultramarine Blue, Burnt Sienna and a touch of purple and, with your no. 6 bristle brush, block in the trees. Finish them out with your no. 4 script brush, thinning the mixture to an ink-like consistency for the script brush work.

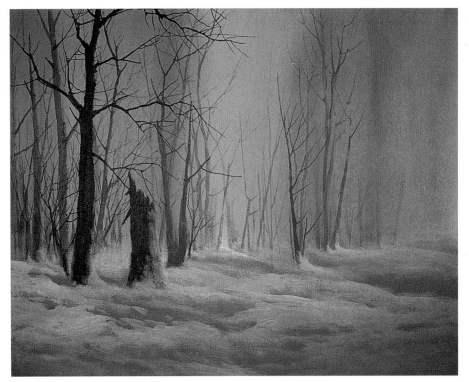

6 Highlight Snowdrifts, Phase 1
For this step, you want to create a mixture of white and a touch of yellow and orange; this mixture should be only slightly tinted. Make it fairly creamy, then grab your no. 6 bristle brush and drybrush in the highlights that create the drifts of snow. All you want to do is locate the basic forms of the drifts; we will put the final highlights on later. Keep in mind, as usual, that you have good negative space throughout the drifts so that you have good eye flow; also, notice the soft edges.

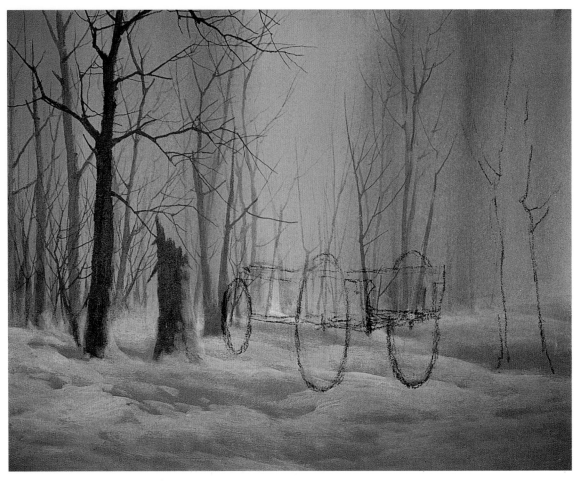

7 Sketch In Wagon and Tree
This will be a little test of your drawing skills. Take your charcoal and make a rough but fairly accurate sketch of the wagon and the large tree on the right. Note: Sometimes a soft charcoal pencil is easier to sketch with because you can sharpen it like a pencil and it holds its point better.

8 Underpaint Wagon and Tree

This is not too difficult to do, but you do need to be careful. First, mix a color that has a nice gray tone to it; Ultramarine Blue, Burnt Sienna, and a little white with a touch of purple should do it. Now, with your no. 4 flat bristle brush, block in the body of the wagon and the large dead tree. Don't block in the wheels yet; we actually need to finish the body of the wagon before adding the wheels. See how the top of the tree fades into the background; this helps create the effect of mist.

9 Detail Wagon Body

What you will do here is change the underpainting color to a lighter value by adding a little white. Then, take your no. 4 flat sable brush and drybrush long strokes along the sides of the wagon to suggest weathered wood. You may need to repeat this a couple of times until you are satisfied with the results. Then, take your script brush with a dark mixture of Ultramarine Blue and Burnt Sienna and paint in a few cracks and holes to make the wood appear very old. Now, take the highlighted snow color and paint in some snow on top of the side panels and in the floor of the wagon. Now we are ready for the wheels.

10 Add Wagon Wheels

There is no magic formula for painting these wheels. The best thing is to have a fairly accurate sketch, then make a medium-dark mixture of Ultramarine Blue, Burnt Sienna and a touch of white. Make the mixture fairly creamy, then take your no. 4 round sable brush and carefully paint in the wheels. This is a fairly difficult task because of the angle of the wheels, so take your time and be careful! Once the wheel is painted, slightly lighten the mixture and paint the outer rim of the wheel so it looks three-dimensional. You can also paint the snow on top of the wheels, spokes and hubs, as you did on top of the wagon body.

11 Paint Clumps of Grass

Now it's time to put in all the clumps of grass. For this, you want to mix Burnt Sienna with a touch of purple and a little bit of blue. Take your no. 6 bristle brush and drybrush in the clumps in the depressed areas of the snow. Keep in mind, this is only the background for the taller weeds to come later. Scatter these clumps so that you have good eye flow throughout the snow.

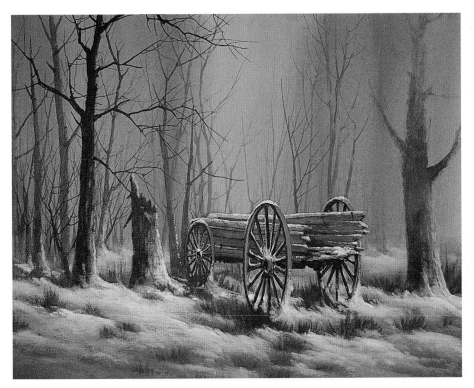

12 Highlight Snow, Phase 2

This step is fairly similar to step 6, except that we are more specific with the application of the highlights. First, mix the highlight color of white with a touch of yellow. Make it nice and creamy, then take your no. 4 flat sable brush and drift the snow up against the clumps of grass and the tree trunks, along the sides of the trees and against the wagon. Notice how the snowdrifts are on the right side of the trees and clumps of grass; this gives the effect that the wind is blowing from the right to the left.

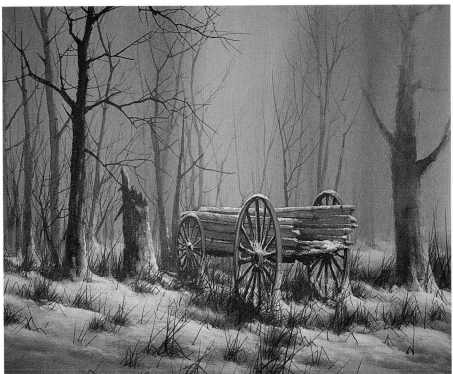

13 Add Taller Weeds

This is the step that really ties the painting together. Mix a very inky mixture of Burnt Sienna and a touch of purple. Now, take your no. 4 script brush and paint the taller weeds coming out of the clumps of grass we added earlier; then, in selected areas throughout the foreground, add individual weeds. Notice that many of the weeds overlap each other, and some are very stiff and bent over. The idea here is to make the weeds look cold or frozen.

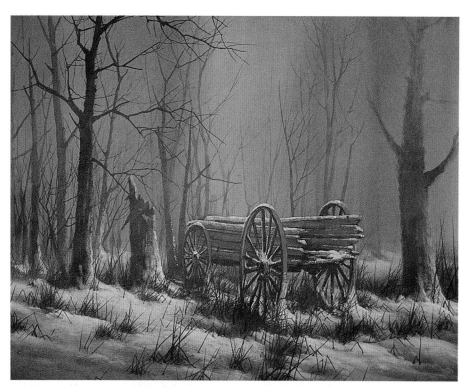

14 Glaze Background

Glazing is something that you should be familiar with by now, but if not, refer to the front of the book for more detailed instruction. Notice here that the glaze has a sharp angle to it, with visible brushstrokes to suggest a slight breeze. Your glaze color here is a mix of white with a slight touch of orange and, of course, plenty of water. Now, evenly load your hake brush and gently skim the surface of the canvas at an angle, until you have created a nice soft directional glaze.

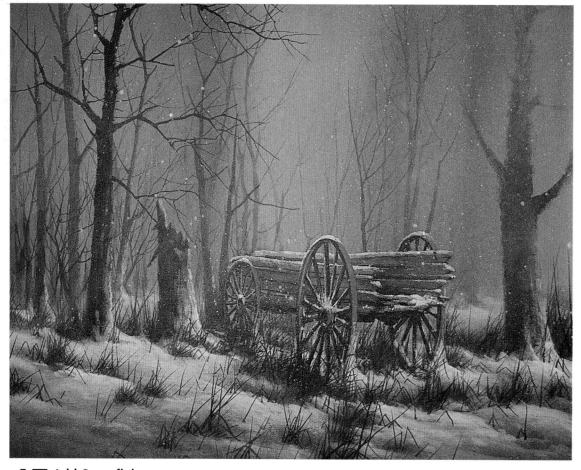

15 Add Snowflakes

This is really a fun step. Simply wet the entire canvas, then with a toothbrush and pure white paint, flick snow onto the wet surface. The individual dots of snow will bleed slightly, creating a variety of sizes of soft snowflakes. You might want to practice this step on a scrap canvas first.

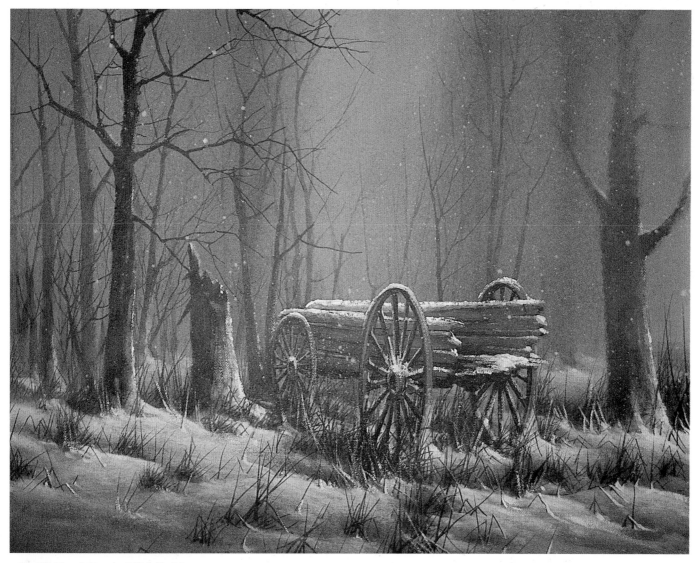

16 Final Snow Highlights

This step is designed to add the final highlights to the snowdrifts and, in fact, add more drifts up against the taller weeds to settle them down. Then, highlight any other area, such as the trees or wagon, to give the painting its final light. For this, use a mixture of white with a slight touch of yellow. Use any brush that fits the area you want to highlight. Generally your sables work best here.

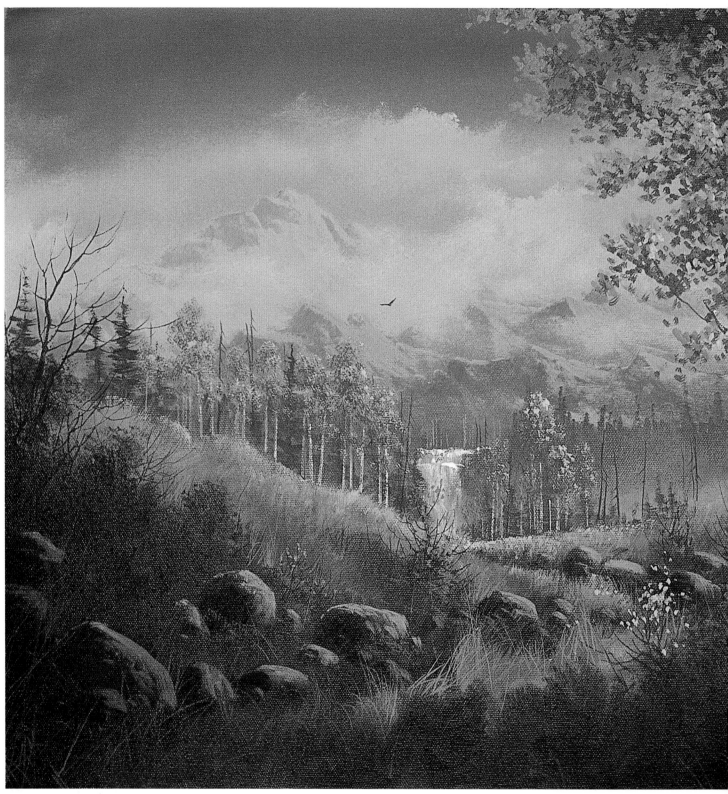

Autumn Fog in the High Country
16" x 20" (41cm x 51cm)

Autumn Fog in the High Country

I can't help but recall my years living in Angel Fire, New Mexico—in my opinion, a true artistic paradise. An early morning fog drifting in and out of the mountain ranges can be enchanting. The great thing about being artists is that we can create this feeling anytime we want to. In the front of the book, we discussed the technique of painting fog. In this painting, we get to use that technique in a practical application. One of the things that I would really like for you to do is to do this painting without fog, and then do it again with the fog. I think you will be amazed what a difference the fog makes in the atmosphere. Another thing this painting does for you is it gives you another opportunity to practice rocks, mountains and clouds, and it gives you a chance to paint many artists' favorite season, autumn. The aspen trees in this painting also offer you a unique and challenging opportunity. It looks like you might have your work cut out for you, so get ready for another painting experience.

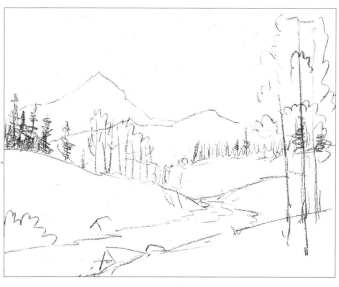

1 Make Rough Charcoal Sketch

We have to begin this painting with a fairly good but rough sketch of the basic layout of the landscape.

2 Paint Sky

Because this painting has a good bit of fog in it, we want the sky to have a soft, warm gray tone to it. So, lightly wet the sky with your hake brush, then apply a fairly liberal coat of gesso. While the gesso is still wet, beginning just above the mountains, use pure orange with a little yellow and blend it all the way up to the top of the canvas. While this is still wet, take Dioxazine Purple and a touch of Ultramarine Blue and, starting across the top, blend downward with large X strokes until you have a very soft blended sky. We will add clouds after we paint the mountains.

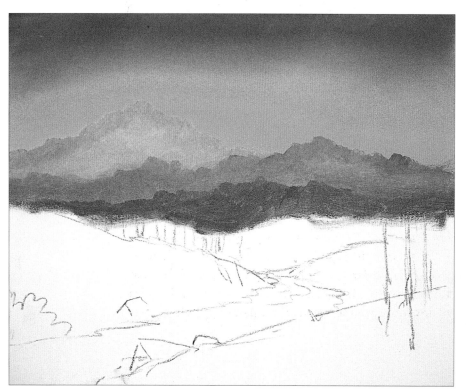

3 Underpaint Mountains

Notice the three layers of mountains. We will mix a basic mountain color and change the value for each layer. Mix Ultramarine Blue, a touch of Burnt Sienna, purple and enough white to change the value so that it is slightly darker than the sky. With your no. 6 bristle brush, block in the most distant mountain first. Now, darken the mixture slightly and paint the next layer. And finally, make the mixture a little darker and paint in the final range of mountains. You should have three distinct value changes.

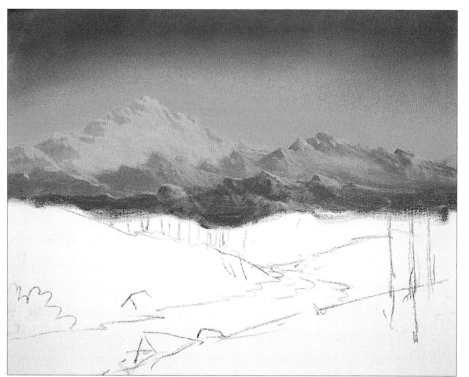

4 Highlight Mountains

Before we can add the clouds and fog, we need to highlight the three layers of mountains. For this, we need to mix white with a touch of yellow and orange; this should be a fairly creamy mixture. Use your no. 4 flat bristle brush and carefully drybrush in the highlights on the first mountain range; keep the highlights fairly soft. Add a little more orange to the mixture and highlight the middle range. The front range doesn't have much highlighting, but it needs enough to define it. Now we are ready for the fog and the clouds.

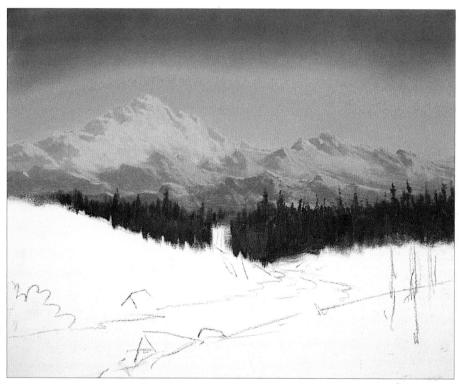

5 Paint In Distant Pine Trees

These trees are a major part of the fog study. They need to be very soft and muted so that they blend into the fog. First, mix white with a little bit of Hooker's Green and purple; make sure this value is not too dark. Now, take your no. 6 bristle brush and, with a dry-brush vertical stroke, paint in a nice collection of pine trees down toward the center of the painting, ending near the waterfall.

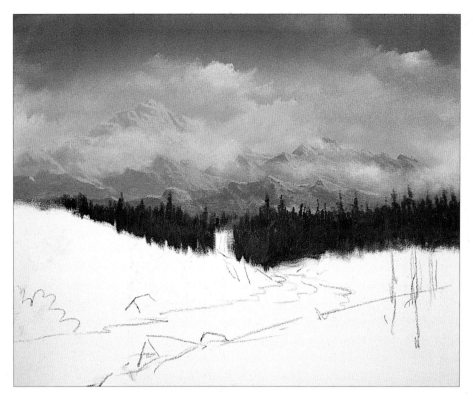

6 Add Fog and Clouds

Mix white with a very small amount of orange, just enough to tint it. Now, take your no. 6 bristle brush and scrub in the clouds; keep the clouds very soft with good negative space. Gradually work the clouds over the first range of mountains, and be sure some of the mountain shows through; now, repeat this in front of the second mountain range. Make sure that there are no hard edges.

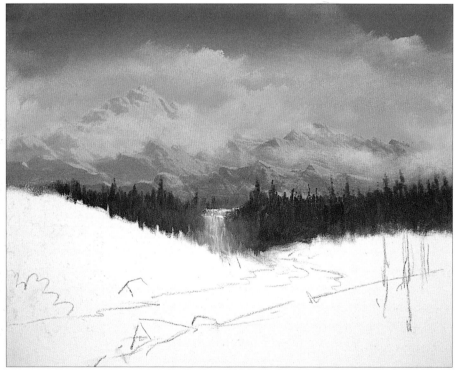

7 Paint Waterfall

This is not as difficult as it looks. First, with your no. 6 bristle brush, underpaint the area where the waterfall is with a medium bluish gray mixture of white with Ultramarine Blue and a touch of Burnt Sienna; blend this color into the background so there are no hard edges. Now, with your no. 4 flat sable and pure white, drybrush in the waterfall. Remember, this is a very distant waterfall, so you don't need to add any detail. Keep it simple.

Note: Be sure the bluish gray mixture for the underpainting is completely dry before you add the waterfall.

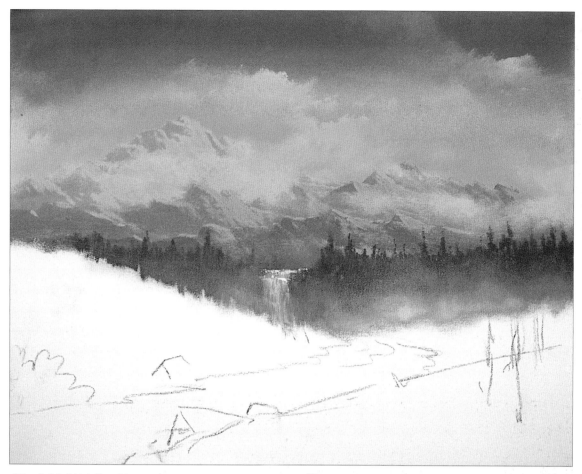

8 Add Middle-Ground Fog or Mist

The area just below the distant pine trees will be a large patch of fog or mist. We mix this with white and a little bit of Ultramarine Blue. Now, take your no. 10 bristle brush and scrub in the fog, until the entire area is covered.

9 Paint Middle-Ground Pine Trees

For this step, you want to mix Hooker's Green and a touch of purple and white. Adjust the color and the value so that it's not too green or too dark. This is a very important transition step between the background and the foreground, so the value has to be just right. Now, take your no. 4 flat bristle brush and paint in a nice collection of soft middle-ground pine trees. This is a good time to practice your negative space rules; just be sure you have a good variety of shapes and sizes.

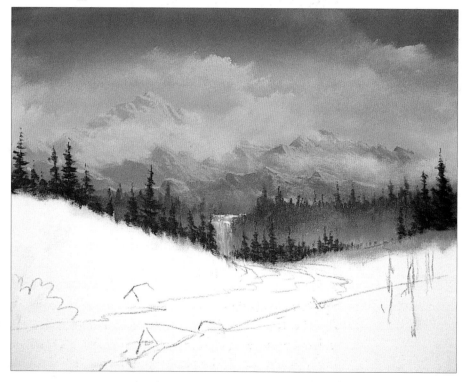

10 Underpaint Middle-Ground Meadow

Since this is the autumn of the year, we want to use good clean soft autumn colors, such as yellows, golds, oranges, sienna and soft purples; you will need your no. 10 bristle brush for this. Starting at the top of the hill, apply yellow with touches of Burnt Sienna. Apply the paint very thick across the top of the hill, then, using a vertical stroke, pull upward, creating the suggestion of a grassy mountain meadow. While the paint is still wet, apply successive layers of yellow, orange, Burnt Sienna and purple, pulling each layer up against the other, overlapping each layer slightly to create subtle contrasts. You have to work very fast with this so that each layer blends into the next before it dries. Continue darkening the grass until you reach the foreground. You should have a fairly three-dimensional hill, with three distinct value changes of light, middle and dark.

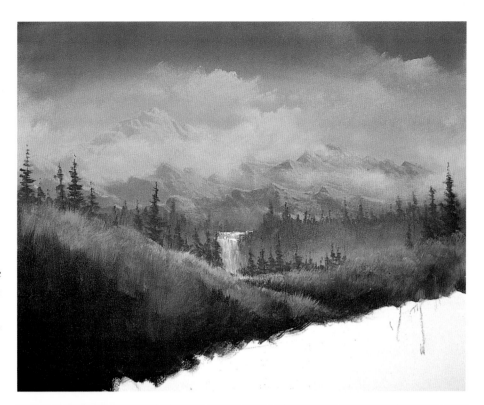

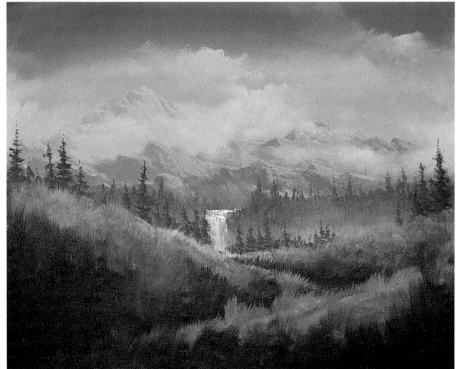

11 Underpaint Foreground Grass

This step is identical to step 10, except that you will use longer and looser brushstrokes. A slight angle of the grass to the left will give the suggestion of a light breeze. One thing that will be helpful here is to add the shadow from the large aspen trees. Don't be afraid to use loose free Impressionistic strokes. Your no. 10 bristle brush works best here. The best color for the shadow is Burnt Sienna and purple.

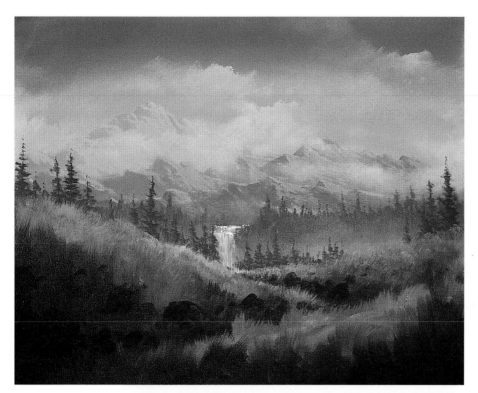

12 Underpaint Rocks

Begin with a mixture of Burnt Sienna, Ultramarine Blue, Dioxazine Purple and a little bit of white to soften it. Now, take your no. 6 bristle brush and block in the dark side of the rocks. Once again, create good negative space along with a good variety of shapes, sizes and some overlapping.

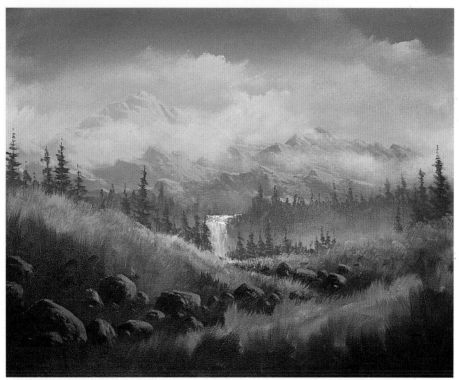

13 Highlight Rocks

For this step, mix white with a touch of orange, then add a slight touch of purple to gray the highlight. Remember, all we want to do here is create the basic shape of the rocks. We will add the final highlights later. Use your no. 4 or no. 6 flat bristle brush for this step and quickly apply the highlight to the top right side of each rock. Notice the brushstrokes that show up here; this is what makes rocks look rocky and rough.

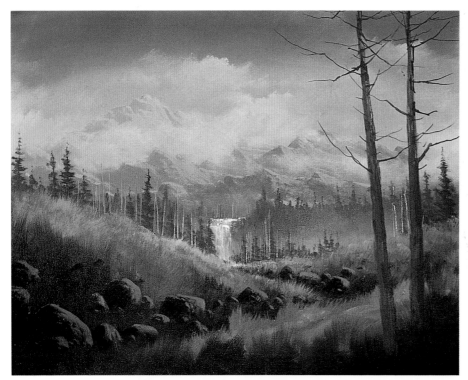

14 **Block In Aspen Tree Trunks**
You may want to sketch in these trunks first with your charcoal. Even though aspen tree trunks are a soft white, we still need to underpaint them with a gray tone. So, mix Ultramarine Blue, a touch of Burnt Sienna and white to create a nice gray. Then, with your no. 6 or no. 4 bristle brush, simply block in the shape of the trunks. Thin the mixture to an ink-like consistency, then take your script brush and add some of the smaller limbs. Add a little white to this mixture to create a lighter value, then go ahead and paint in the aspen trees in the background.

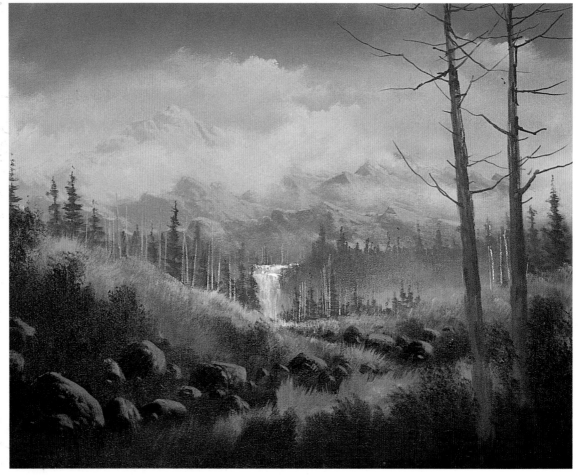

15 **Add Foreground Bushes**
Notice the bushes on the left of the painting, and around the rocks, and at the base of the aspen trees. You need this darker value to create a contrast against the lighter grass. This mixture is made up of Burnt Sienna and Dioxazine Purple. Make the mixture slightly creamy, then take your no. 10 bristle brush and dab in these bushes.

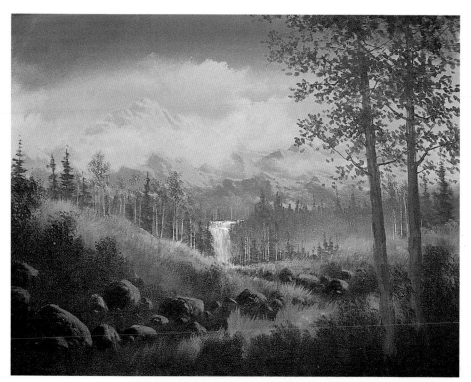

16 Underpaint Aspen Trees

For this step, we will use Burnt Sienna with a touch of purple. Take your no. 4 flat sable brush and scumble in the larger masses of leaves, keeping the edges of the clumps very soft. Then add occasional individual leaves to help tie the clumps together. Now, you can slightly lighten the mixture with a little white and scumble in the leaves of the aspen trees in the background.

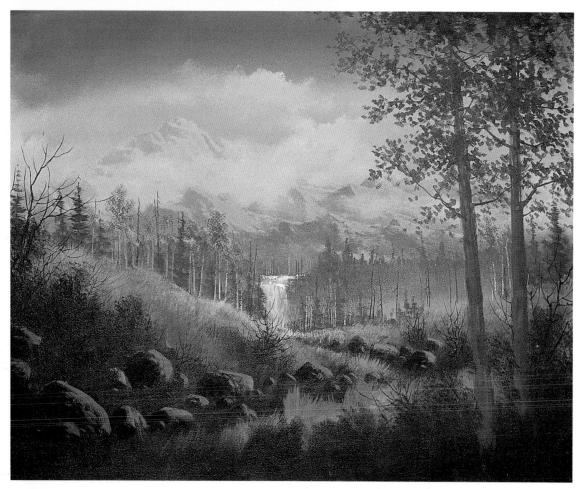

17 Add Small Dead Bushes and Trees

This should be a familiar step by now. So, grab your script brush and create a mixture of Burnt Sienna and Ultramarine Blue, making it very ink-like. Paint in the dead bushes in the foreground, then lighten the mixture slightly and paint in the distant dead pine trees. This would be a good time also to add any additional limbs to your aspen trees.

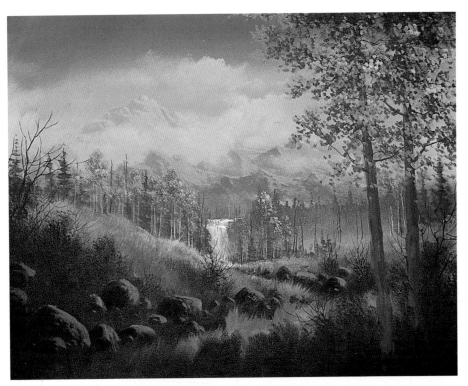

18 Highlight Aspen Leaves

Here, you want to use a combination of yellow, orange and Burnt Sienna in different combinations and/or as individual colors. Make the mixture creamy, then take your no. 4 flat sable brush and highlight the aspen leaves with a series of overlapping comma strokes. In some places you will want some individual leaves scattered around. Switch to your no. 4 round sable brush to highlight the background aspens.

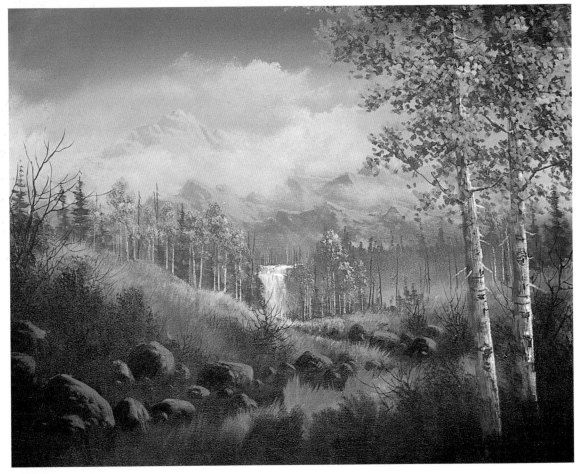

19 Highlight Tree Trunks

This is a fairly easy step. Mix white with a touch of orange, making it fairly creamy. Then take your no. 4 flat sable brush and, using a series of short choppy strokes, highlight the right side of the trunks. Notice these trunks have little eyes in the bark; leave some of the background showing through to create this effect. Use your script brush to highlight the background aspens.

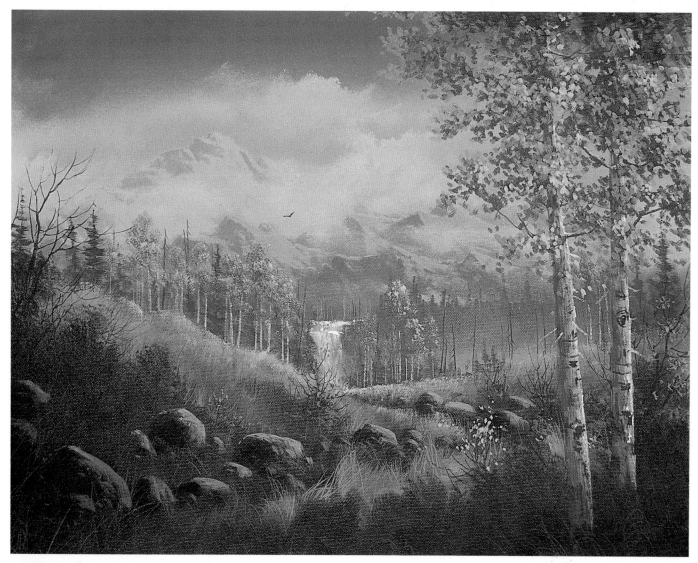

20 Add Final Details

This is where your artistic license will serve you well. Adding final highlights on the rocks, aspen leaves and pine trees will add the autumn glow that the painting needs. Feel free to leaf some of the dead bushes in the foreground or add a few mountain flowers. And then, of course, the taller weeds in the foreground round out the composition.

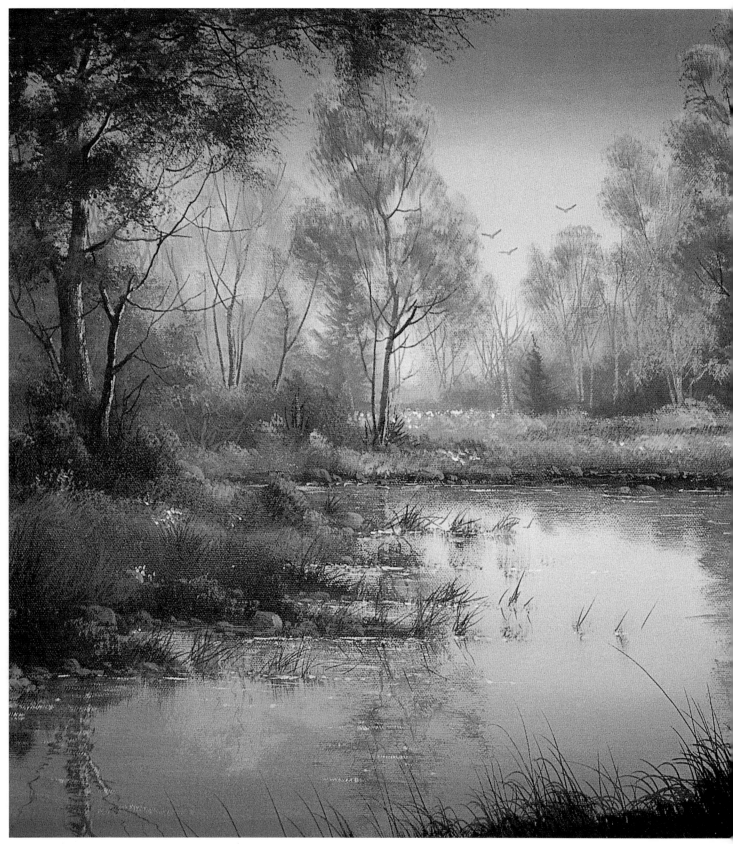

Spring's Song
16" x 20" (41cm x 51cm)

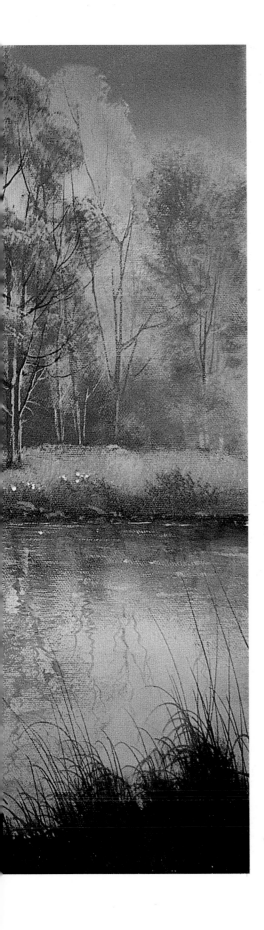

Spring's Song

Springtime in Oklahoma, where I am from, means storms and sometimes tornadoes; however, the northeast part of the state where I have my studio is called "green country" and the springtime can be absolutely breathtaking. In this painting, **Spring's Song,** *we are going to practice several of the techniques that we discussed in the front of the book. The first thing that you will get to work on is a wide variety of live trees, where you will get to practice some leafing techniques. Another thing you will get to work on is calm water and reflections. One other area that is quite challenging is the use of the color green, one of the more difficult colors to master. In this painting you can see we use a wide range of values and tones of green, which will really help you expand your painting horizons. This is a fairly simple painting in terms of composition, but the trees will challenge you. The key is to keep the trees soft and give them good form, which means, of course, watch your use of negative space. Have fun!*

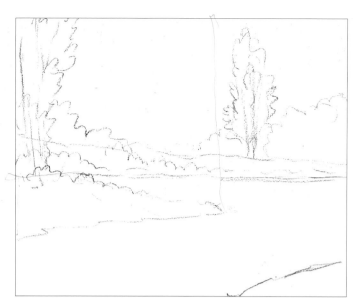

1 Make Rough Sketch

Not much sketching is needed here, just the basic location of the background trees and the lake in the foreground. Your soft vine charcoal works well for this.

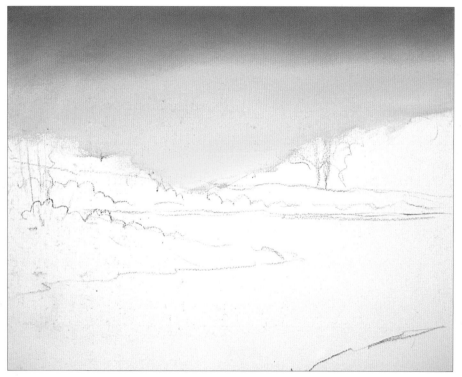

2 Paint Sky

We want a clean, crisp and clear sky to help get the early spring look. Begin by lightly wetting the sky with your hake brush, then apply a liberal coat of gesso. While the gesso is still wet, begin at the horizon with pure yellow and blend your way upward until it fades almost to the top. Then, immediately take Ultramarine Blue and a touch of purple and, starting at the top, blend downward until the colors are blended together so that you have a very soft sky. It's OK if the sky turns slightly green toward the center.

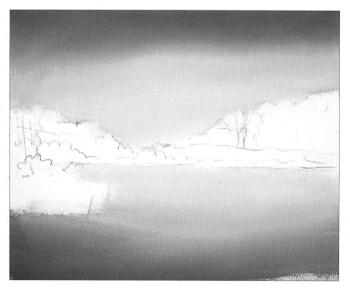

3 Paint Water

This step is nearly identical to step 2; the only difference is that you paint upside down. What I like to do here is turn my canvas upside down and paint the water. Simply repeat the process from step 2, and then the water will be ready for reflections.

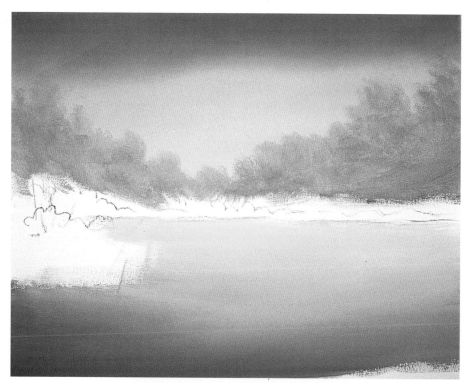

4 Add Background Trees

Now, this first layer of background trees is very pale to create distance and a bit of a hazy look. For this, mix white with Dioxazine Purple and a touch of Hooker's Green. Now, take your no. 10 bristle brush and dab in a nice formation of distant trees. Notice how pale they are against the yellow horizon.

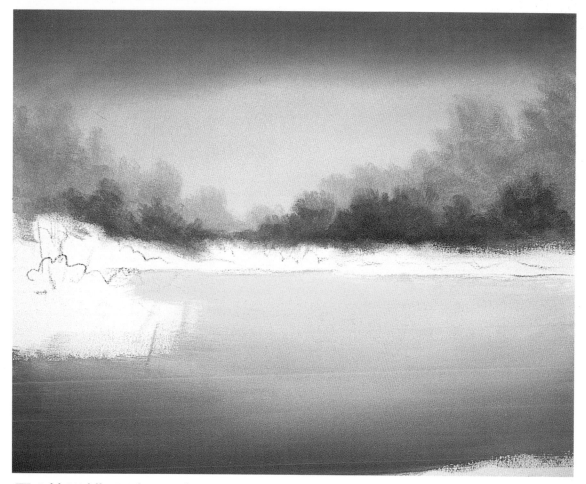

5 Add Middle-Background Trees

For this step, use the same color we started with in step 4, except you want to darken it a little bit with a little more green and purple. Now, take your no. 10 bristle brush and dab in this collection of trees. Notice the trees in the middle of the painting are much smaller than the trees to the far left. The main thing is to be sure that you have a good variety of shapes and sizes.

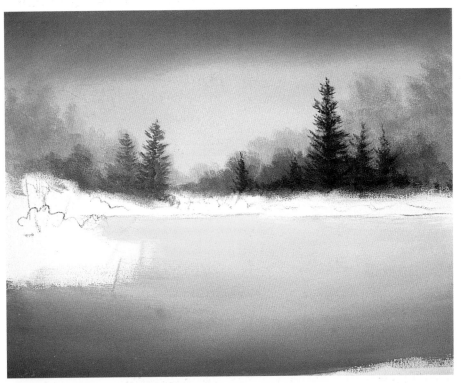

6 Paint Cedar Trees

For this step, mix Hooker's Green, a little purple and a little Burnt Sienna. A touch of white may be added to get the correct value. Now, take your no. 6 bristle brush and paint in the cedar trees. These cedar trees are a very important part of the middle-ground composition and overall balance of the painting. It's important that they have soft irregular edges.

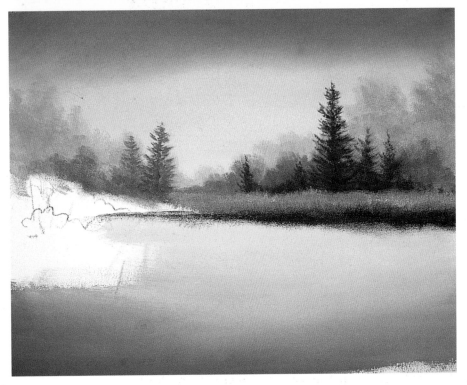

7 Paint Middle-Ground Grass

This is a small area and, at the same time, a very big part of the painting. What works best here is a combination of Thalo Yellow-Green and a touch of orange. Now, take your no. 10 bristle brush and apply this paint fairly thick; while it is still wet, put your brush flat against the canvas and push up to create the effect of grass. When you get to the water's edge, add Hooker's Green and a touch of purple and smudge in a darker shoreline.

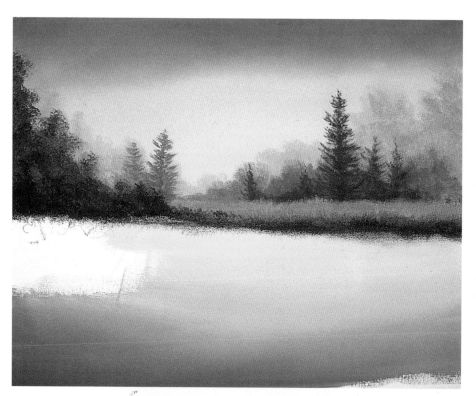

8 Underpaint Middle-Ground Trees

As you can see, we are getting closer to the front of the painting, so each successive layer of trees gets darker. So, this mixture will made of Hooker's Green, a touch of Burnt Sienna and Dioxazine Purple. Now, take your no. 10 bristle brush and dab in the trees on the left side of the painting. Don't hesitate to make minor value changes within this group of trees by adding more or less of the original colors plus touches of white and Thalo Yellow-Green.

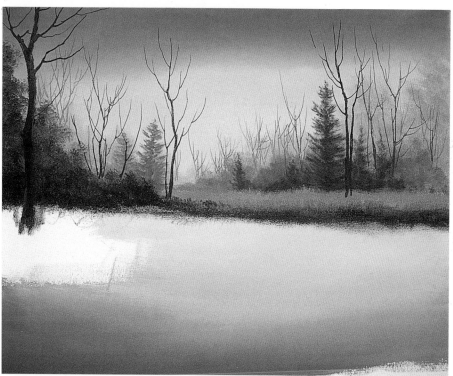

9 Block in Tree Trunks

We need to create a base gray mixture of Ultramarine Blue, Burnt Sienna and a little white. From this base mixture, you can lighten or darken it according to your needs. We are going to paint in all of the tree trunks from the background to the foreground. You may need to use two or three different brushes; probably your no. 4 round and flat sable and your no. 4 script brush will work best. Beginning in the background, start with your lightest value and work your way forward, making each value slightly darker.

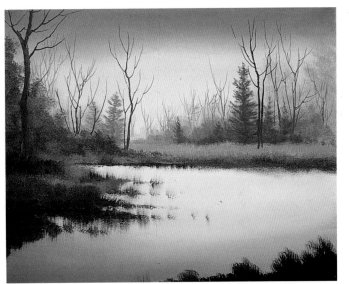

10 Underpaint Foreground Grass

Notice the foreground grass on the left of the painting. This area really ties the background to the foreground. We use a combination of colors here to create different shades of green. Begin with Thalo Yellow-Green, touches of yellow and orange, and then add Hooker's Green to help create darker shades. When you get to the water's edge, add a little purple to darken the shade. Use your no. 10 bristle brush and loose vertical strokes to create the suggestion of grass. Be sure as you pull up the grass that you use a soft touch so the grass will have soft edges.

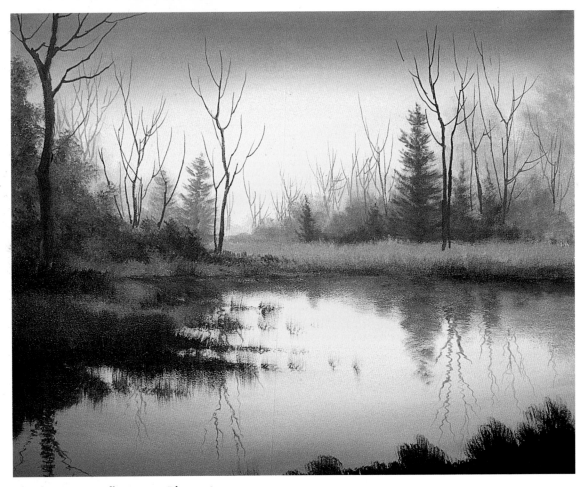

11 Paint Reflections, Phase 1

The reflections in this painting are absolutely the key to its success. The best way for me to explain how to create them is as follows. Look at the objects that are reflected—the background trees, middle-ground trees, cedar trees, tree trunks and grassy areas. Go back to the steps where these objects were created, and in the same order they were created. Take the color and lighten the value by about one degree, then with your no. 4 flat bristle brush, using a horizontal scrubbing stroke, paint in each reflection, making sure the edges are soft and slightly blurred. Once these reflections are finished, we will then finish the rest of the painting and add the final reflections at the end.

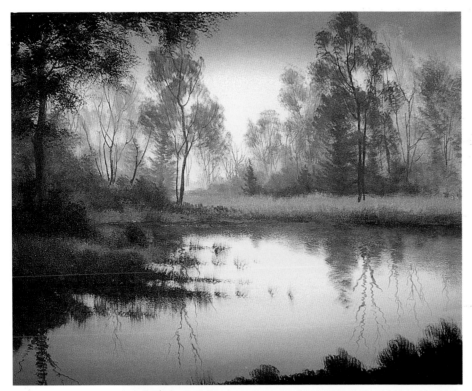

12 Add Leaves to Tree Trunks

This step requires careful planning. You can use a variety of greens, but keep in mind this is a spring painting, so you want to keep your greens fairly clean. I suggest a base green of Hooker's Green and a touch of purple. From this base green, you can add touches of Thalo Yellow-Green, yellow and/or white. You can create dozens of spring shades. Then take your no. 10 bristle brush and dab in leaves throughout the painting where the tree trunks are. Remember to change the value of the color to fit the location of the leaves by adding white. You know the rule: lighter in the background, darker as you come forward.

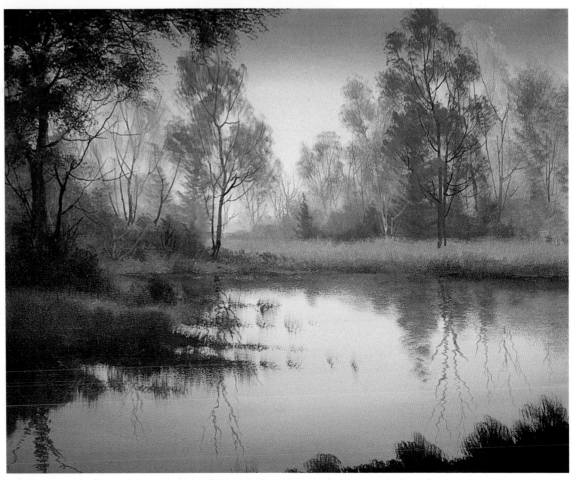

13 Add Final Tree Limbs

Now, with your script brush, take your tree trunk colors and add additional limbs to complete your trees and bushy areas.

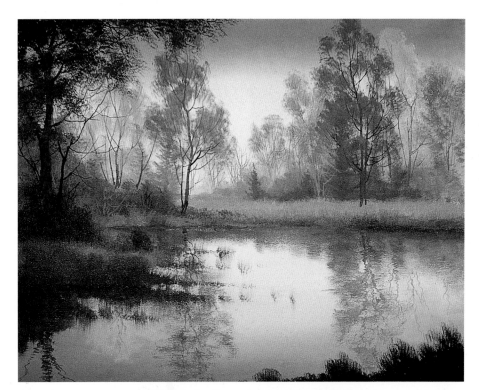

14 Add Final Reflections, Phase 2

At this point we need to add any reflections from objects that we have added, such as tree leaves, limbs, grasses, and so on. The technique we use here is the same as in step 11, so you might refer back there for a reminder.

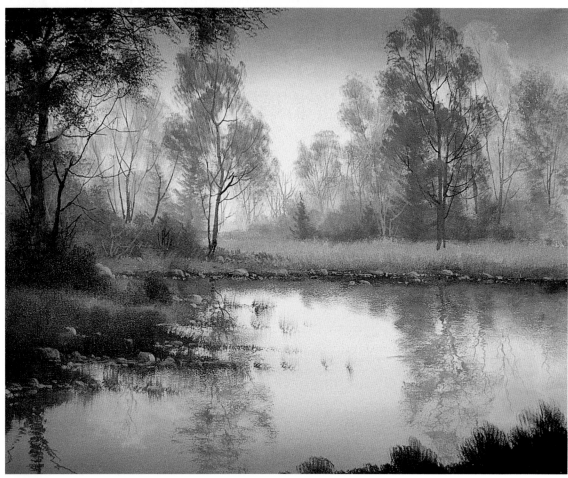

15 Paint Small Rocks Along Shoreline

For this step, take your no. 4 flat sable brush and a mixture of white with a touch of orange; add just a slight touch of blue to gray the mixture. Then, along the shoreline, create the suggestion of small rocks. Just be sure not to line them up in a row with the same shapes and sizes. These rocks are only accents, not features.

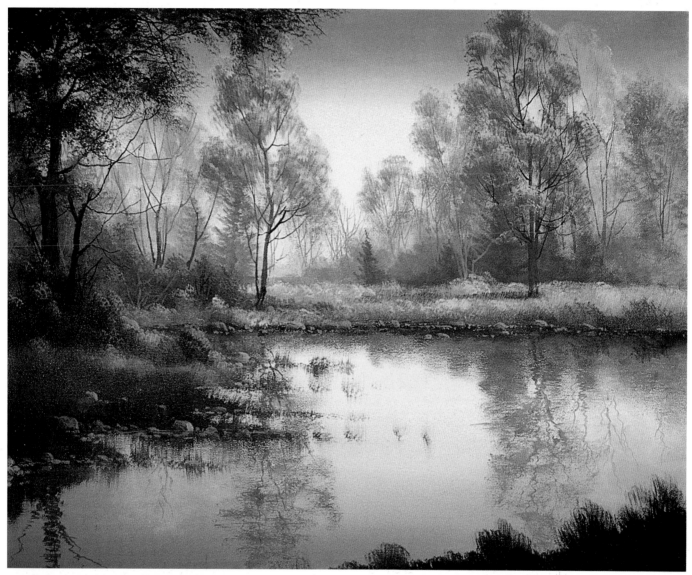

16 Highlight Bushes and Trees

This is a good place to have fun with your artistic license. Use a wide variety of highlight colors, such as Thalo Yellow-Green, white, yellow mixed with white, Thalo Yellow-Green mixed with yellow. You can even use some warmer tones by adding a little orange to the above colors. Now, work all through the painting, adding pockets of light to create more complete three-dimensional forms to your underpainted trees and bushes. Also, add highlights to some of the grassy areas. Your no. 6 or no. 10 bristle brush works best for this.

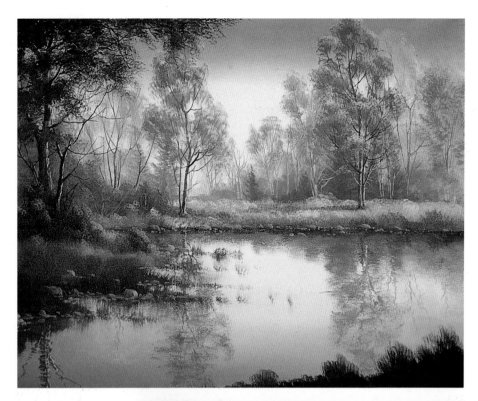

17 Highlight Tree Trunks

For this highlight color, mix white with a touch of yellow and orange. Now, with your no. 4 round and/or no. 4 flat sable, apply a nice clean opaque highlight along the right side of all the tree trunks. On the larger trunks, you may want to create the suggestion of bark by using short choppy vertical strokes.

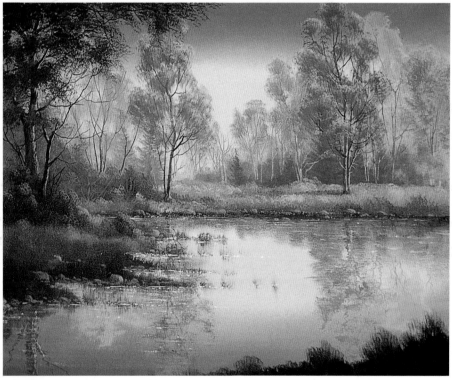

18 Glaze Water

This is a step most of you have done before; it's really quite simple. Take your hake brush and create a glaze of water and a touch of white. Load your hake brush evenly across the tip. Then, starting from the left to the right, turn your brush vertical to the canvas and gently drag it across the surface of the water with a slight wiggle in the stroke. Now, form a very sharp chisel edge with your brush; take pure white and gently add some thin horizontal highlights along the edge of the shoreline.

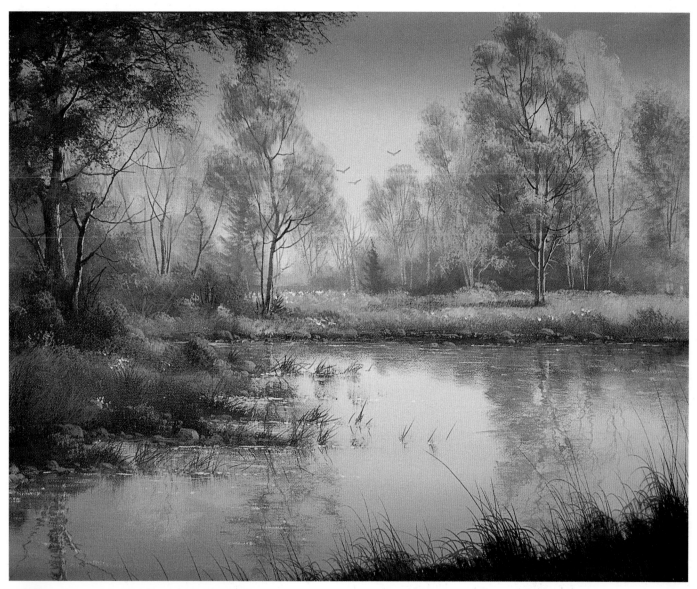

19 Add Final Details and Highlights

This is where your own personality takes over. You can add things like complementary flowers, tall weeds or even a small dogwood or redbud tree in the background. The important thing to remember is to use complements of the greens—pinks, reds, oranges and soft purples. Use only accents; it won't take too much to bring your painting to life. You probably will want to use your no. 6 bristle brush to dab in these accents.

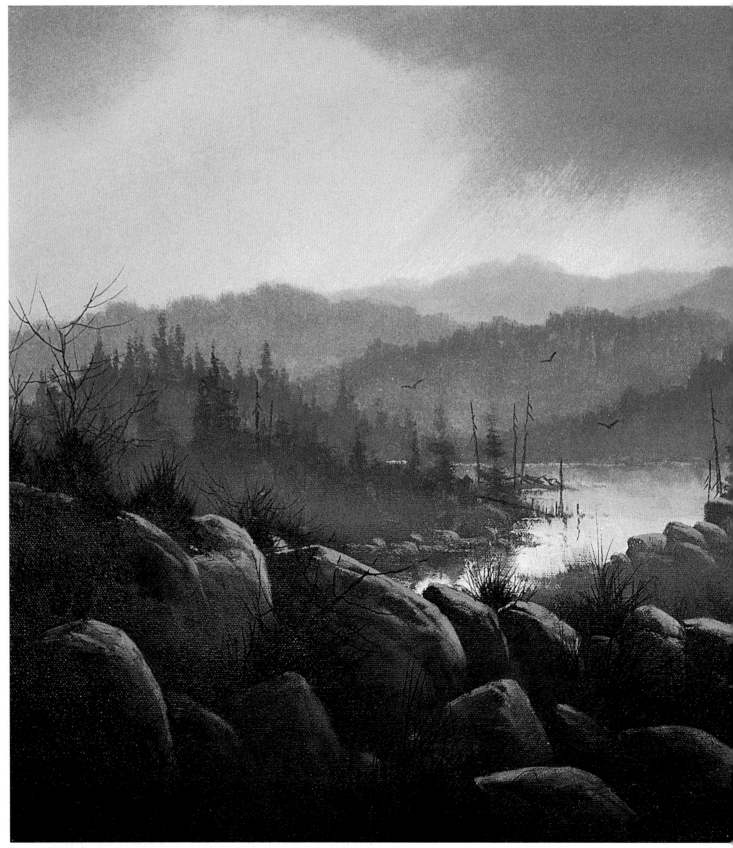

You Can See Forever
16" x 20" (41cm x 51cm)

You Can See Forever

This is a very unusual and exciting painting to do. In the front of the book, creating rocks was one of the different techniques we discussed, and although we have painted rocks in some of the other paintings, in this painting the rocks are one of the main features. Also notice the tremendous depth in this painting. Many of you struggle with this because you don't understand the proper use of values. In this painting I will teach you how to mix different values to create this kind of depth. We will also practice painting the fog or mist that helps separate the different layers of mountains. And finally, you will learn how to use different shades and values of grays. Gray may seem like a neutral and uninteresting color, but believe it or not, gray is really an artist's best friend. This painting is full of opportunity, so have fun experimenting, and I promise you will be happy with most of your results.

1 Create Basic Sketch

You can see many layers of depth here, so it's important to create a rough sketch showing the different layers. Use your soft vine charcoal for this.

2 Paint Sky

We want a slightly stormy sky here, maybe with a hint of distant rain showers. So, take your hake brush and lightly wet the sky area, then apply a liberal coat of gesso. While the gesso is still wet, take a little orange and paint a soft orange tint over the entire sky. While this is still wet, start on the right side with a mixture of Ultramarine Blue and a little Burnt Sienna. Blend this mixture on the canvas from right to left, gradually fading from dark to light. Once you have blended this, take your brush and use a light angled feather stroke to create the suggestion of distant rain and/or wind.

Note: The next few steps are very similar to each other. As simple as they may seem, each step is critical so that the value is absolutely correct. As we move closer to the foreground, not only do the values get darker, but we begin to add more creative shapes to each hillside.

3 Mix Base Value

All we do in this step is mix our base value color. Take gesso, half as much Ultramarine Blue, a quarter as much Burnt Sienna and a touch of purple. Refer to the color swatch here to check your color and value. Mix a fairly good-sized pile of this, then add just enough water to make it creamy.

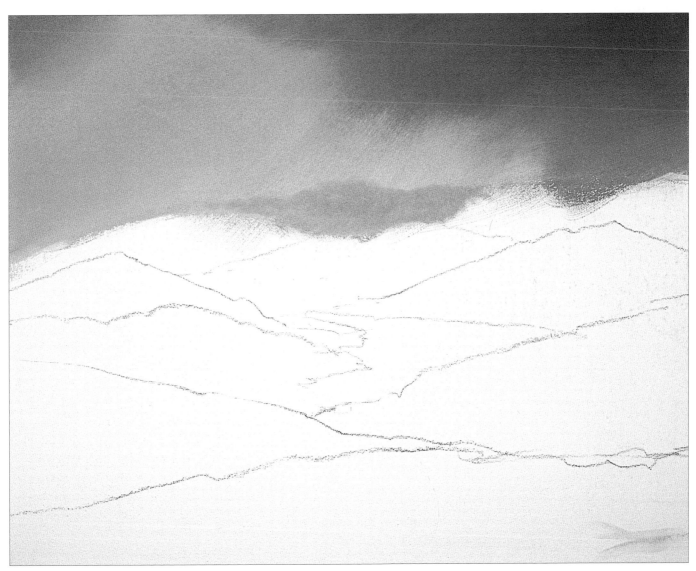

4 Scrub in Distant Hill 1

Now, take a little bit of the base value and add just enough white to make it slightly darker than the sky on the left side. Take your no. 6 bristle brush and scrub in the first hill. Be sure it has a nice soft edge; it's OK if part of it blends into the sky.

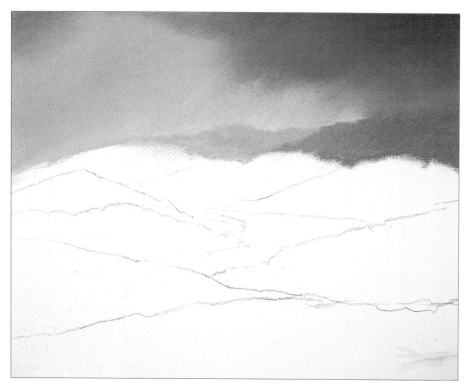

5 Paint Distant Hill 2

This step is just like step 4, except the shape of the hill is different; also notice that the right side blends into the sky, which helps create the effect of rain or low clouds and fog. Remember to keep edges soft and use your no. 6 bristle brush. The value for this is slightly darker than for hill 1.

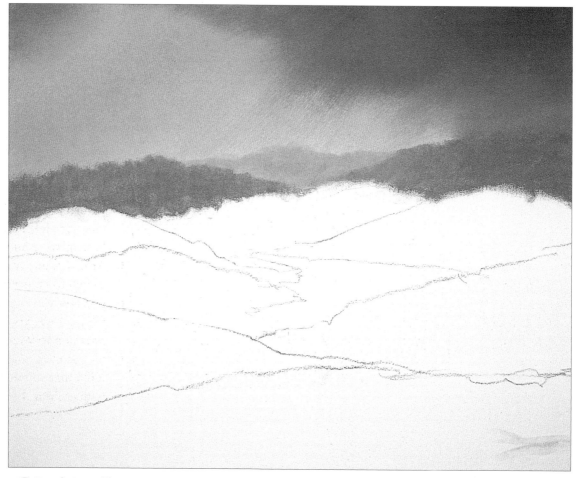

6 Scrub in Hill 3

You can see now the process of gradating the values. So, for hill 3, slightly darken the base color and take your no. 6 bristle brush and scrub in a different and unique shape; but notice the top of the hill is beginning to show the suggestion of very faint tree shapes.

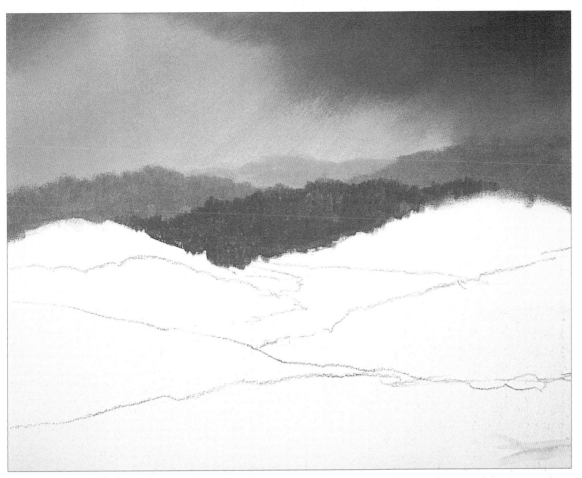

7 Add Hill 4

No secret here. Simply darken the value so it is slightly darker than hill 3. Now, you can really begin to see more definite tree shapes. So, after you scrub in the main shape of the hill, take your brush and dab in more recognizable tree shapes.

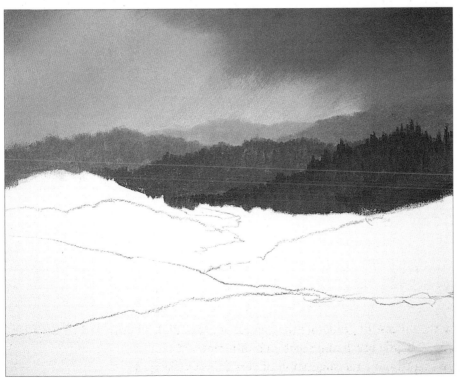

8 Paint Hill 5

This is the hill just before we reach the lake. Slightly darken your base mixture and scrub in this hill. At this point, you may want to switch to your no. 4 flat sable brush and create even more distinct tree forms. Now, you need to pay close attention to your negative space as you paint in your trees; just keep in mind that soft edges are important with each of these layers.

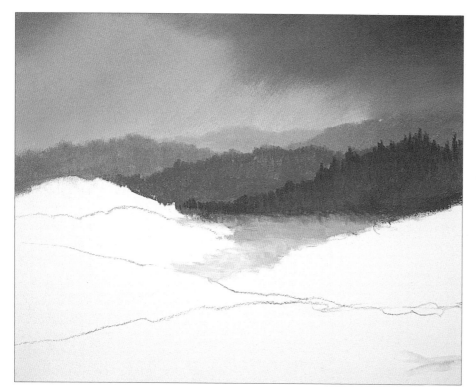

9 Block in Lake
All we do here is take the sky color that you see above hill 4, which if you remember, is a mixture of white, a touch of orange, blue and Burnt Sienna. With your no. 6 bristle brush, simply block in the water area. Be sure to make the area a little larger than the finished lake will be.

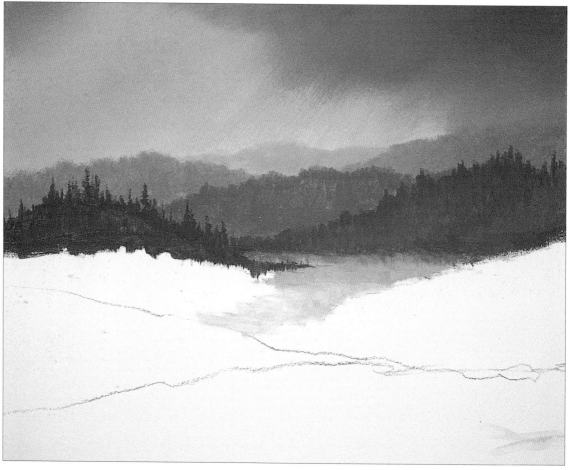

10 Add Hill 6
This hill, as you can see, takes on a much more distinct form, and the trees are taller with more defined shapes. So, as we have been doing, slightly darken the mixture that we used in step 8, then take your no. 6 bristle brush and go to work, being very creative with the shapes and forms.

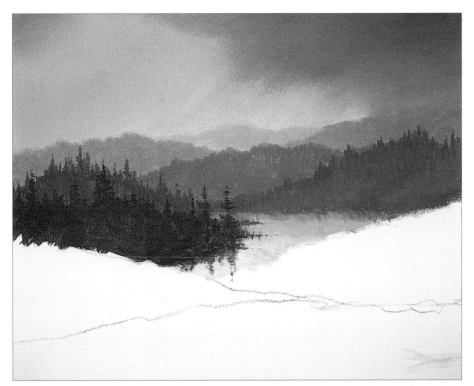

11 Add Hill 7

This hill is almost identical to hill 6. Of course, the value is slightly darker and the trees have different shapes, but the technique is the same. Notice, though, that these trees are a little more distinct. Continue using the no. 6 bristle brush here, although you may want to switch to your no. 4 flat sable to do the trees.

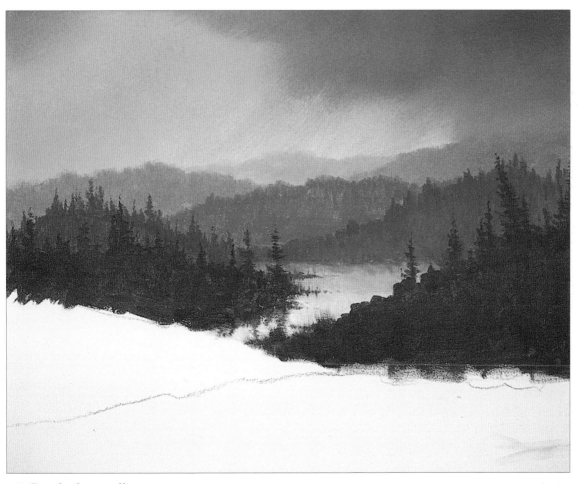

12 Block in Hill 8

This is the last hill before we get to the foreground. It's a small area, but important nonetheless because it helps to balance the painting. This value is similar to the value used in step 11. Even though it is not much darker, it is enough to make a difference. So, go ahead and block it in with your no. 6 bristle brush, and then we are ready to move into the foreground.

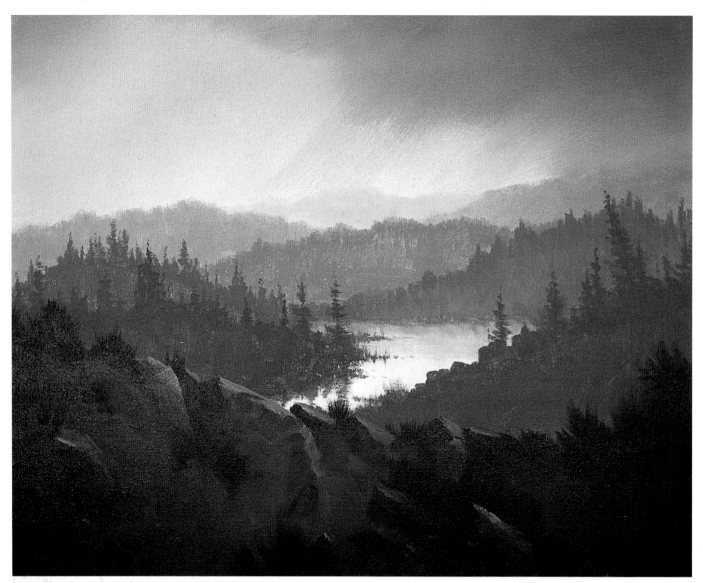

13 Underpaint Foreground Rocks and Bushes

Now that we are in the foreground, we need to change the value and color. So, take the original base color we used for the hills and add Hooker's Green and purple. Be sure this value is very dark. What we want to do here is create a good variety of bushes, clumps of grass and some irregular ground formations. Take your no. 10 bristle brush and dab in these different formations. As you come forward, add touches of white to the mixture to create some soft light areas, then go back to the dark mixture to create some contrasting forms; at the same time, you want to create some basic rock formations. Just darken the mixture we were just using with a little more blue and a little Burnt Sienna. Because this is such a dark foreground, it's important to go ahead and highlight the rocks with a very soft gray to help establish their form; I usually add a little white and orange to the rock color to create this soft gray tone. We will put the brighter highlights on in the next step. This foreground needs a good composition, so keep a careful eye out on your negative space.

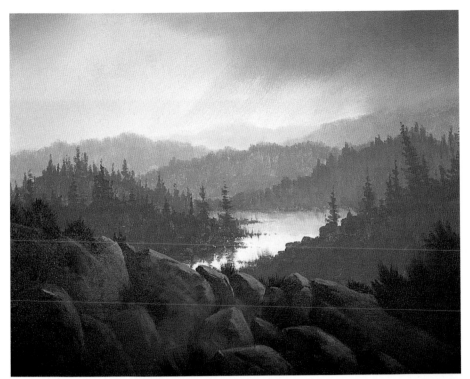

14 Highlight Rocks

Highlighting these rocks can be a little tricky. We don't want them to be too bright. So, take the shadow color and add a little bit of white and orange; this will create a nice soft, warm middle-tone gray. Now, with your no. 4 bristle brush, highlight every rock carefully so each has a distinct shape but soft edges. We may add brighter highlights later.

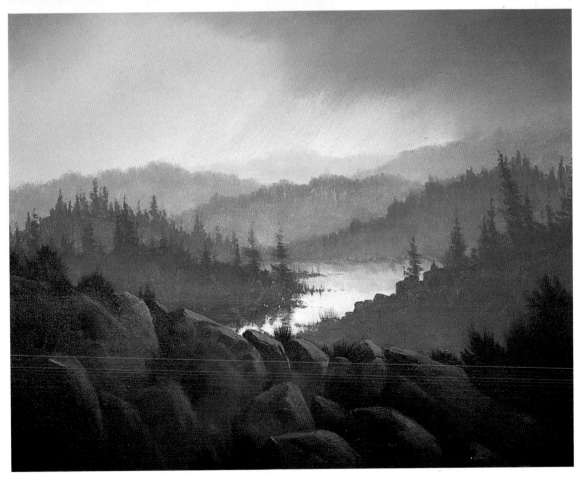

15 Scrub in Mist Between Mountains

For this step, you want to mix a soft mist color. Mix white with a touch of orange and Ultramarine Blue. Now, load your no. 6 bristle brush with a very small amount of this mix and scrub in the mist between the layers of mountains. The key is softness, so be sure you don't leave any hard edges. I discovered that if you thin the mixture down a little bit, it will scrub on easier.

Index

Painting has never been more fun!

Learn how to act upon your artistic inspirations and joyfully appreciate the creative process! This book shows you how to develop the skills you need to express yourself no matter what unusual approach your creations call for! Experiment with and explore your favorite medium through dozens of step-by-step mini demos. No matter what your level of skill, *Celebrate Your Creative Self* can help make your artistic dreams a reality!

ISBN 1-58180-102-5, hardcover, 144 pages, #31790-K

Discover a range of techniques for painting expressive "portraits" of your favorite homes and buildings—from cottages and barns to mansions and cityscapes.

 This is some of the most comprehensive step-by-step instruction ever published by North Light Books, covering everything from perspective and composition to painting stone, brick, wood and other textures. No matter what your medium is or how long you've been painting, these "keys" will help you unlock exciting new possibilities in your art.

ISBN 0-89134-977-4, paperback, 128 pages, #31415-K

Through 15 step-by-step watercolor demonstrations you'll learn essential techniques for mixing colors, creating textures and setting moods for an impressive range of subjects. Each exercise is packed with the details and insights you need to succeed.

 Whatever your skill level, you'll become proficient at capturing the beauty and power of trees, rocks and mountains, while simultaneously refining your own painting style.

ISBN 0-89134-975-8, paperback, 128 pages, #31610-K

These books and other fine North Light titles are available from your local art & craft retailer, bookstore, online supplier or by calling 1-800-289-0963.